NATURAL ARCHITECTURE

copublished by
Princeton Architectural Press
37 East Seventh Street
New York, New York 10003

For a free catalog of books, call 1.800.722.6657. Visit our web site at www.papress.com.

22 Publishing S.r.l.
via Morozzo della Rocca, 9
20123 Milan, Italy

www.22publishing.it

for Princeton Architectural Press
editor LAUREN NELSON PACKARD

Special thanks to: Nettie Aljian, Dorothy Ball, Nicola Bednarek, Janet Behning, Becca Casbon, Penny (Yuen Pik) Chu, Russell Fernandez, Wendy Fuller, Jan Haux, Clare Jacobson, John King, Mark Lamster, Nancy Eklund Later, Linda Lee, Katharine Myers, Scott Tennent, Jennifer Thompson, Paul G. Wagner, Joseph Weston, and Deb Wood of Princeton Architectural Press — Kevin C. Lippert, publisher

for 22publishing
series director ALESSANDRO ROCCA
book design No11, Inc.
editor MARIA FRANCESCA TATARELLA
graphic design FABIO SOLETTI / No11, Inc.
translation of the Italian text STEVE PICCOLO

Image credits, cover: Patrick Dougherty (front), Mikael Hansen (back)

Library of Congress Cataloging-in-Publication Data Rocca, Alessandro. Natural architecture / Alessandro Rocca. p. cm. Includes bibliographical references.
ISBN 978-1-56898-721-7 (alk. paper)
1.Site-specific installations (Art) 2.Nature (Aesthetics) 3.Environment (Art) 4.Plants in art. 5.Art, Modern—21st century. I.Title. N6498.I56R63 2007 702.8'1—dc22
2007002703

Princeton Architectural Press New York

NATURAL ARCHITECTURE

ALESSANDRO ROCCA

The pioneers of natural architecture

We see nature today as a universe in rapid mutation. New concepts and images developed by scientific research find immediate echo in information and entertainment media. They spread, influencing and transforming the gaze and the perceptions of the general public. In our collective imagination nature is still that idyllic theater in which we can sense primordial vital forces, but it is also a presence with multiple forms, the most effective of all manifestations of the predominance of uncertainty and risk. We see nature as goodness and beauty, but also as the most terrifying violence. It is the best representation of our idea of infinity, but also the maximum expression of order and chaos, due to the complexity of its relations and the impossibility of any technical procedure to provide a reliable simulation of its doings that will be comparable to the original model. Our relationship with this world in movement becomes increasingly difficult and complicated, while taking on growing importance and urgency as a necessary way of balancing out the dominion of technology and industrialization of rural activities: hunting, livestock raising, cultivation of crops. And all this is joined by the urgent ecological emergency: the indiscriminate consumption of natural resources has led to a worldwide environmental crisis, and today we are all experiencing the problems involved in living in conditions with excessive levels of contamination.

Art registers all this, forecasting and amplifying reflections and sensations, giving material expression to submerged nightmares and visions, giving form to emotions, developing concepts. On the other hand, scientific developments have radically altered the coordinates of that basic artistic practice that consists in the representation and imitation of nature. Until the end of the nineteenth century, paintings were made of forests, seascapes, urban views, and *déjeuners sur l'herbe*, as nature offered a scenario that may not have been simple, but was nevertheless always accessible, an immediately comprehensible reality. In the twentieth century avant-garde art came to terms with the rise of the civilization of machines and nature was replaced, with great rhetorical efficiency, by artifice. A permutation that took on different aspects: caption-like versions, as in the universe of pipes and gears of Fernand Léger; mythological versions, as in the Futurists' praise of speed; psychoanalytical versions, as in the work of most of the Surrealists (Max Ernst, Joan Miró, René Magritte, Salvador Dalí), or linguistic approaches, as for Marcel Duchamp and Dada. Toward the end of the 20th century, starting in the 1960s, the thrust of the avant-gardes scattered in a thousand streams, while new forms of artistic expression were also established: happenings, performance art, multimedia. At the same time, art abandoned the closed spaces of galleries, moving outdoors to discover uncontaminated places. This new avant-garde was guided by the Land artists—Robert Smithson, Walter De Maria, Michael Heizer—who (temporarily) left the galleries of Manhattan's West Side to make large works in remote locations in the Wild West: the deserts of Nevada, Utah, California, and New Mexico. The movement had great impact and its openness to the landscape destroyed the automatic relationship between work and exhibition space. From that time on, every site was virtually eligible to be occupied and redeemed by art, and this new freedom of action led to a whole series of subsequent outdoor experiences applied to situations of all kinds: countryside, sculpture parks, decaying outskirts of cities ushered in by the reconnaissance missions of Robert Smithson, and in the centers of cities, with the rise of Public Art. A series of progressive slippages that push the work toward the confines of artspace, in search of a path toward an operative relationship with the reality of places, opening new, more direct and effective channels of communication with the audience.

The conventions of art exhibition were subverted. Art was no longer closed off in separate enclaves, but instead

became an aggregating force operating to give a sense of identity to lost places. The direct display of the work was replaced with an exhibition mode split into two complementary experiences: the display of the preparation materials and photographs or videos of the work at its site, or documentation seen in a gallery or a museum and the work on the site itself, to be visited in a kind of pilgrimage, a new sort of cultural tourism. The return to nature, its themes, and materials represents a significant component of this vast process of restructuring the artistic dimension. A component that, along with the environmental issues mentioned above, has now become the center of very pronounced attention. In keeping with the motto "with nature alone," artists and architects around the world are working on projects that bear witness to the radical proximity of natural places and factors. The challenge is to re-present, in contemporary terms, the ancient naturalistic idyll, pursued by filtering the beauty and authenticity of natural elements and landscapes through the culture and sensibility of our time and by agreeing to confront the simplest of sentiments—belonging, alliance, complicity with the natural world—with the unshakeable complexity of the world as it appears to us today.

Art - nature - architecture

Today's naturalism is dominated by the effects of scientific progress. The imitation of nature finds its models in the dizzying realm of biotechnological microcosms, the macrocosms of astrophysics, the enigmas of fractal modularity, the exponential complexity of artificial intelligence, the layerings of genetic manipulation.
In these cases we, the planetary audience hooked on strong emotions, want excess, transgression, paradox, escape. But alongside the most astonishing installation or the most reckless work of architecture we see a little elementary construction, made of branches or stones, delicately placed at the edge of an uncontaminated forest. We've changed channels, the special high-tech effects vanish, and we are left with a few simple, measured gestures, in direct contact with nature, in a lively dialogue with landscape. In this region what counts is the here and now, the seasons, light and darkness, the consistency of logs and stones, the sounds of the woods. In the middle of a meadow, on the banks of a stream, in the courtyard of a museum, someone is building something, using only his hands and a few tools, wood, stone, willow boughs, leaves, bamboo. We watch the work of an artist or an architect who, perhaps helped by a group of men and women, constructs a small pavilion, a tower, or in any case a special place, different from all others. These are relatively simple works, crafted—often made over weeks or months—of patient manual labor. The long schedule and measured pace generate a rugged beauty that is archaic, at times, or vaguely surreal, far from the glossy technological paradigm behind nearly all merchandise and objects of all kinds. These works—at least most of them— cannot be defined as environmentalist or ecologist, but they do generate an unexpected approach to the natural world. They use natural elements without rhetoric to take possession of a place, forming a pact with nature that, in most cases, is temporary. With the passing of time the assembled elements of the work continue in their customary processes: wood rots, stones fall, trees grow and then die, the construction ends up completely dissolving. The most humble elements—twigs, pebbles, straw—are used with the same simplicity with which prehistoric man built his dwellings, starting with the materials found at the site: site-specific operations. The huts made by today's artists have nothing primitive about them. They activate precious contacts between our modernity and a range of gestures and

figures that apparently do not belong to our time. Natural architecture calls for the observer, the user of the work, to take on the status of its inhabitant, however temporary, taking possession of the dwelling to perceive the work from inside, as a microcosm, a domestic enclosure ready to be occupied and experienced. The representation of the human figure, already erased by Land Art, is absent, replaced by the presence of man in flesh and blood, with an active role as the inhabitant of these symbolic temporary abodes. The human body returns, then, to its place as protagonist of space, using the relationship typical of architecture, i.e. of bordered and sheltered space, where many makes his habitat and constructs his home. In some cases the architectural metaphor is explicit, in others it is less evident, but it is precisely the will to define a spatial unit that becomes the shared characteristic of all these works, and it is their architectural character that abolishes perception based on contemplation, of the work or the landscape, changing the relationship with the context. The natural environment is no longer interpreted as a passive scenario, as in Land Art, or as an environment to be redeemed, as in the case of the 7000 oaks planted in Kassel by Joseph Beuys and the green Manhattans of Alan Sonfist and Agnes Denes. Instead, it is seen as a generating agent with which to form an alliance, an energy source that feeds the substance and material of the work. In this sense, the radical rejection of modern technology becomes coherent and very significant, avoiding that complex of know-how and techniques many have proclaimed as the heart of the contemporary era, and which has established a utilitarian, destructive relationship with the natural environment. Instead, the relationship is overturned to become cooperative and constructive.

So should we categorize these works as containing antimodern, regressive, nostalgic sentiment? I believe the question should be left open. Without going into the differences—significant ones, at times—between the various artists, I think it is possible to say that each of these works presents more questions than answers, more perplexities than certainties. The production of meanings that are not preconceived and emotions that are not limited is a distinguishing trait of contemporary art, and in this situation of semantic and emotional pluralism lies the expressive force of the particular type of Art in Nature.

Images and spaces of natural architecture

Natural architecture presents a series of constructions that make direct reference to the world of nature in terms of their location, the materials utilized, and a minimal application of non-artisan techniques. Works that use the resources of places, the specific characteristics of the site, growth processes, spontaneous and accidental phenomena, investigating our feelings about nature, testing our sensitivity and our prejudices to suggest a more gentle and friendly, less antagonistic and distracted approach to the natural environment. For the reader, the visitor to this little paper museum, we have tried to prepare a meaningful experience composed of unusual spaces, raw materials, and penetrating odors, to draw on for new stimuli for reflection on the relationship between our civilization, including each of us as individuals, and nature. These works address ecology, landscape, and environment in terms belonging to art: few direct messages, therefore, but a strong capacity to propose new topics in tune with the emotions, sentiments, and culture of contemporary man. Another part of the appeal lies in the unusual, rugged, and often disturbing beauty of these works, forcefully transmitted through drawings, photographs, and reports. Their makers frequent different contemporary art currents—Art in Nature, above all, but also Land, Earth, Environmental, Bio, Conceptual Art—and come from different countries and cultures. There are many representatives of the English-speaking world, balanced out by other figures from Japan and nearly all the main areas of Europe: Germany, France, Italy, Austria, and the Scandinavian countries.

The protagonists of Natural Architecture: David Nash, who through manipulation of the growth of trees has constructed veritable botanical domes; Giuliano Mauri, another master of guided growth, creator of a spectacular living cathedral (Arte Sella, Borgo Valsugana, 2001); Chris Drury, maker of the Time Capsule (South Carolina Botanical Garden, Clemson, 2002), towers of woven branches that preserve an area of completely uncontrolled vegetation, and of the series of the Cloud Chambers, which reflect the image of the sky inside. Other artists use natural engineering to generate highly theatrical happenings, like Marc Bruni & Gilles Babarit, or Mikael Hansen, who builds highways of logs crossing the forest, mysterious Japanese enclosures and pavilions. The small temples, follies and buildings in dreamy sci-fi style by Patrick Dougherty are enlivened and transformed by the use of living trees. In Dreher Park, West Palm Beach, there is a biosculpture by Jackie Brookner, an ecological installation that cleans the city's refluent water. The large works of Ichi Ikeda mark the territory, superimposing episodes of great monumental and narrative impact on its agricultural structure, chapters of a rural epic that invent a completely contemporary moral and aesthetic value for the country landscape that has been damaged and compromised by the civilization of machines. Very interesting, precise technological overtones are found in the structures created by Marcel Kalberer with the German team Sanfte Strukturen, while the poetic installations of Nils-Udo combine lyrical gentleness with harsh violence, as in the extraordinary series of human nests and the subtle manipulations of living plants. Olafur Eliasson builds a big ice umbrella, Armin Schubert uses elements recovered from the Alpine environment to construct volumes and textures, structures and paths that combine the natural character of primordial elements with the rigor of geometric thought. François Méchain erects mysterious figures and spaces that are photographic sets for the production of images that vanish once they have been recorded on film. The installations of Yutaka Kobayashi are also temporary, true theaters of knowledge aimed at explaining the meaning of nature to children through direct contact with animals. The beauty of the installations of Yutaka lies in the joy of the young visitors and in the simplicity with which the animals accept the dwellings he has built for them.

Finally, we should mention certain architects who avoid normal methods to approach alternative philosophies, generating singular, memorable works. Edward Ng, with the architecture students of the University of Hong Kong, has undertaken a program of solidarity. With very limited means and thanks to the collaboration of the English structural specialist Anthony Hunt, he has made an extraordinary bridge that allows the children of a village in rural China to cross a stream and thus reach school. The New York team of nArchitects, composed of the Canadian Eric Bunge and Mimi Hoang, from Vietnam, has created a bamboo canopy structure in the courtyard of PS1, the contemporary art center of MoMA New York. Another young architecture studio, from Barcelona, the Ex. Studio of Patricia Meneses and Iván Juárez, has worked in Senegal to reinterpret traditional fabrics, with a small aedicula offered to the community as a theatrical plaything, a singular spatial experience.

In conclusion, readers should be aware of the fact that many of these works were made in exceptional settings, public and private locations set aside for the creation and conservation of environmental art. These institutions include Arte Sella, the path in Borgo Valsugana connecting thirty-eight installations on this theme; Tickon, the sculpture park in Langeland, Denmark; the Santa Barbara Botanic Garden and the Djerassi Foundation of Woodside, both in California; the South Carolina Botanical Garden in Clemson, a workshop for experimentation on the relationship between art and the natural environment.

DAVID NASH

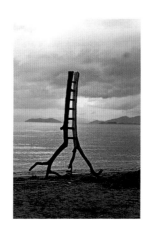

I want a simple approach to living and doing. I want a life and work that reflect the balance and continuity of nature. Identifying with the time and energy of the tree and with its mortality, I find myself drawn deeper into the joys and blows of nature. Worn down and regenerated; broken off and reunited; a dormant faith is revived in the new growth on old wood.

–D. N.

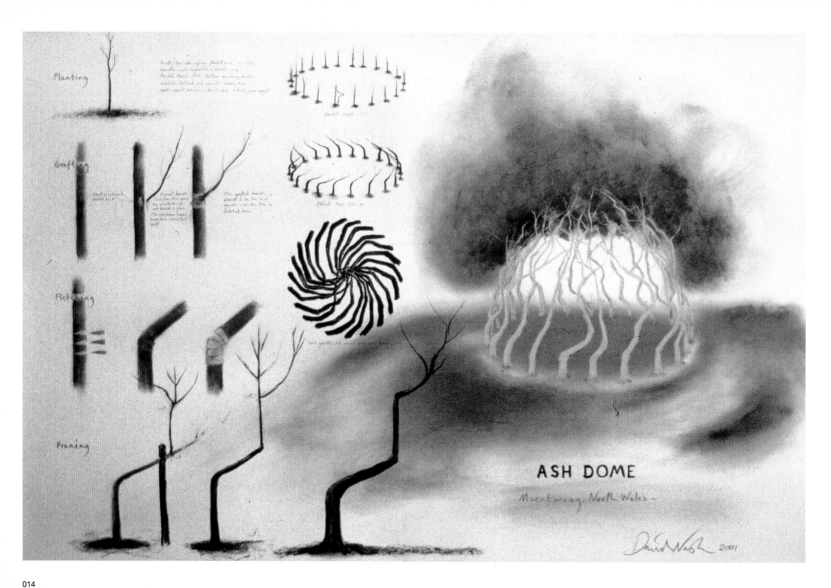

Planting

Grafting

Fletching

Pruning

ASH DOME

Maentwrog, North Wales –

David Nash 2001

"The Ash Dome was conceived as an act of faith in the future: a sculpture for the twenty-first century. A Buddhist tenet, "we get along better if we collaborate with nature instead of trying to dominate it," seemed the way forward. Hedges are a good example. Through a study of hedges, as showed itself to be the most resilient to shaping and able to lean a long way from its roots. Twenty-two ash saplings were planted in a ring thirty feet in diameter on a level area of hillside in the Ffestiniog Valley with the intention of growing a domed space. I am guiding the trees in the manner of the ancient Chinese potters who kept their minds on the invisible volume of space inside their pot and worked the clay up around the shape of that space. Another inspiration was hearing that the British Navy had planted oaks in 1800 to build a fleet in the twentieth century. Sheep ate the first ring of trees so I planted another, this time inside a fence. Rabbit tried to eat the bark of these so they had to be protected. Birch trees were also planted to provide a wind break and act as competition to encourage growth in the ash trees. Using hedgerow methods, mulching, grafting and pruning, the 'ongoing sculpture' has changed over eighteen years from twenty-two thin three-foot wands in an open space to a dense woodland cover where the dome form is discerned by the thickening trunks."

Ash Dome Ffestiniog, North Wales, 1977.

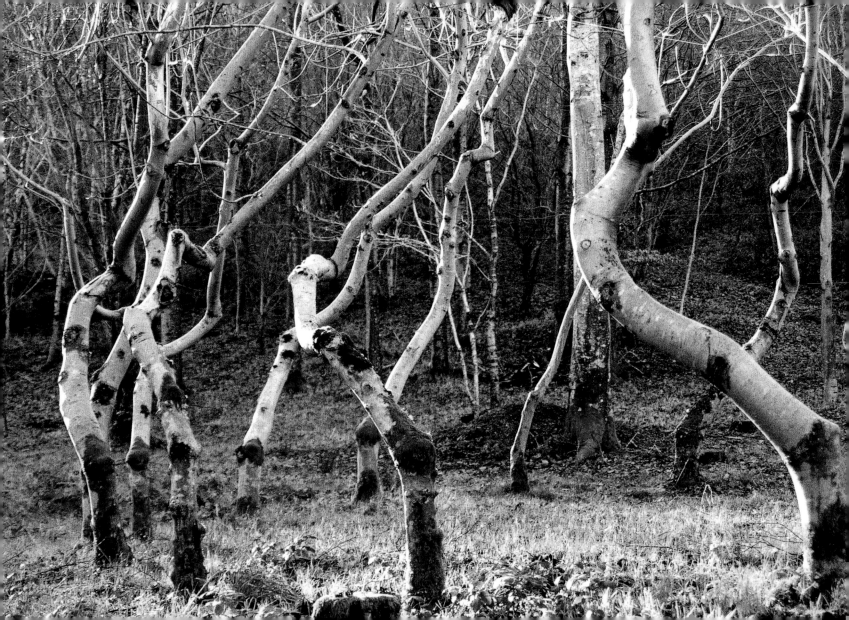

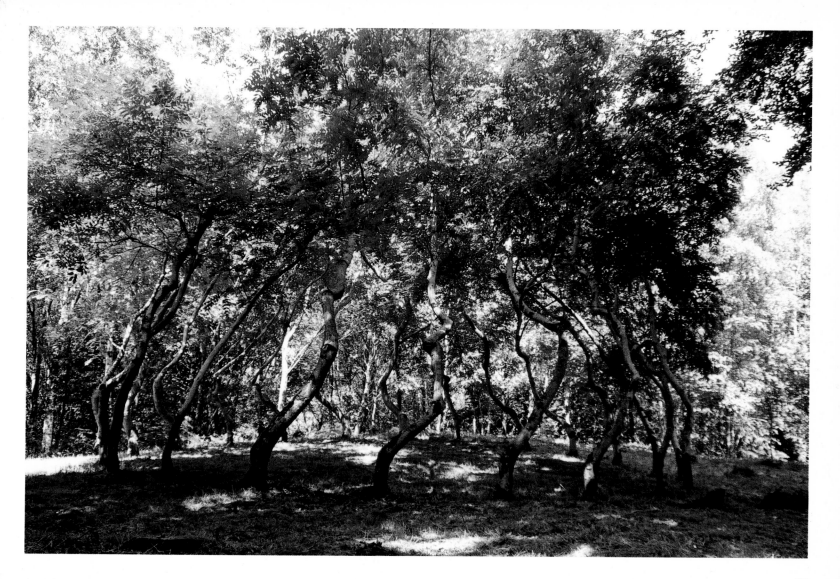

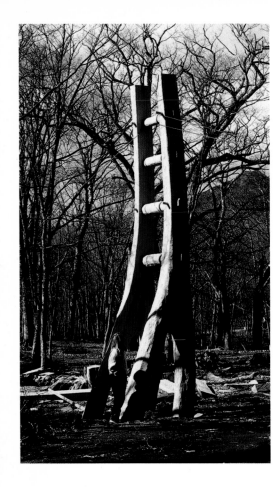

Big Ladder Kotoku, Japan, 1984. Mizunara (white Japanese oak).

Sylvan Steps Woodside, California, 1987. Djerassi Resident Artists Program.

"A linear, self-supporting structure needs at least three legs in order to stand. The image focus becomes the pelvic meeting between the legs and the upper body. The process revealed the image."

In 1987 Nash was invited by the Djerassi Foundation, in the ranch south of San Francisco, to work with several gigantic sequoias that had fallen to the ground. Sylvan Steps is a staircase cut into a robust sequoia trunk that lay at the center of Harrington Creek. In the winter of 1998 the sculpture was swept away by El Niño. It was later found and placed in the picnic grounds (in the photo), in a position similar to its original placement.

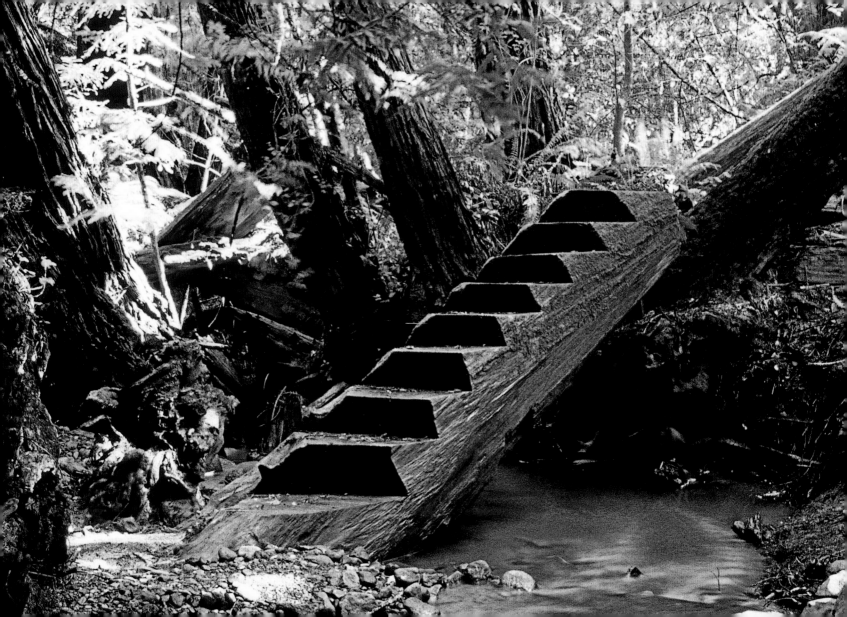

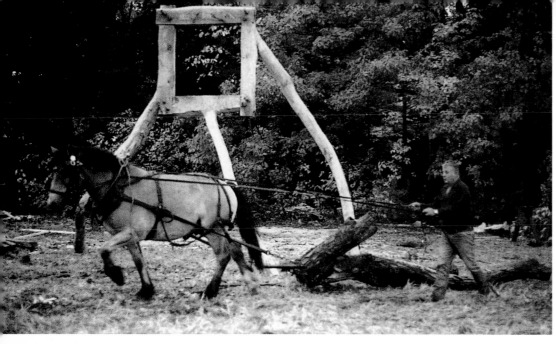

Since the early 1970s the artist David Nash has made sculptures by working with trees. A committed environmentalist, he uses only fallen trees or pruned parts and utilizes the wood without producing scraps. Small branches and chips are transformed into charcoal for drawing. The square frame supported by three legs was made with the wood of two white oak trees of Taylors Falls, Minnesota. In 1994 Nash charred the surface, which had weathered to gray, with a propane torch to give the sculpture a more forceful presence.

"The frame made in Japan in 1984 was installed in Tokyo, outside an Ikebana school. Martin Freedman, the director of the Walker Arts Center in Minneapolis, saw it there and imagined such a sculpture together with a Sol LeWitt sculpture at the Walker. In autumn 1987 a new version of Standing Frame *was commissioned for the Walker. An artist living an hour out of Minneapolis had suitable oak on his land and the facilities for construction. To avoid having to use a tractor to extract the wood from the forest we worked with a horse. In respect to Sol LeWitt I made the interior frame dimensions and overall height exactly the same as the frame sculpture. As with all wood, the outside is gradually turned from its original amber colour to a silver grey. To restore his presence I returned to Minneapolis in 1994 and charred it black."*

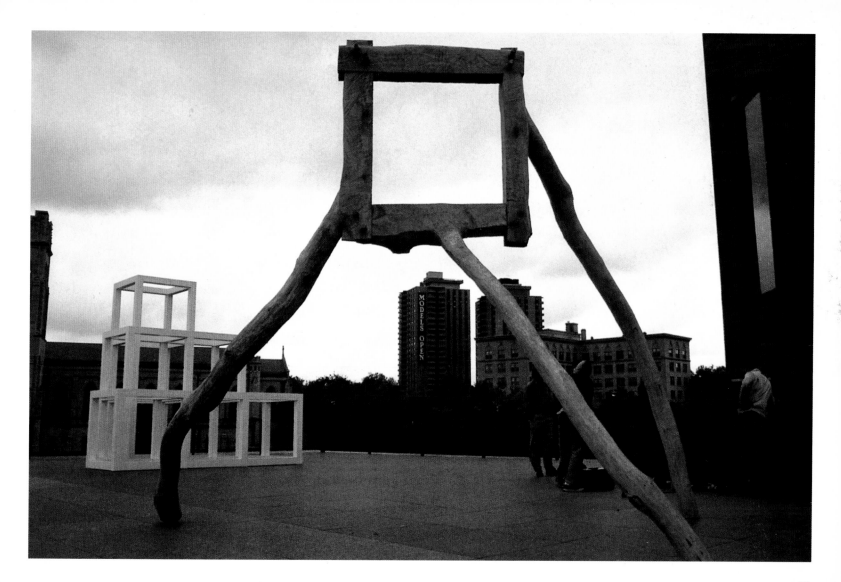

GILLES BR
MARC BAB

NI & ARIT

To materialize a process of temporary
appropriation. A question, above all, of experience—
direct and intense—in which there is no room for
faking it. To react to a place, to make it active or not,
means relying on the data of the site, interpreting the
place and considering its history—in ecological
terms—to adapt to or transform the order of things.

–G. B. & M. B.

The Streampath: clothing the banks for confrontation and cohabitation of the common bed South Carolina Botanical Garden, Clemson University, South Carolina, U.S.A., February 1998.

Stream, streambanks, local stones, quarry stones, dead branches of native trees, collected and trimmed, planting of wild vines, bracken, etc. In situ: A serpentine shape of approximately 230 feet long, 10 to 49 feet wide and 16 to 23 feet high.

"The finished work requires an active spectator. It is an invitation to act/react, not just in implicit agreement with the work, but also due to the experience of the site: frequentation and appropriation. Therefore our installations often include paths that penetrate them and facilitate occupation."

 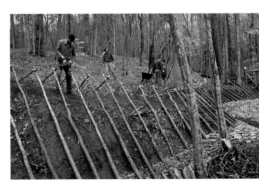

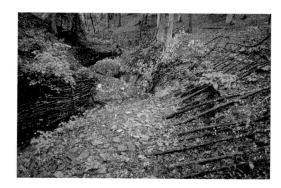

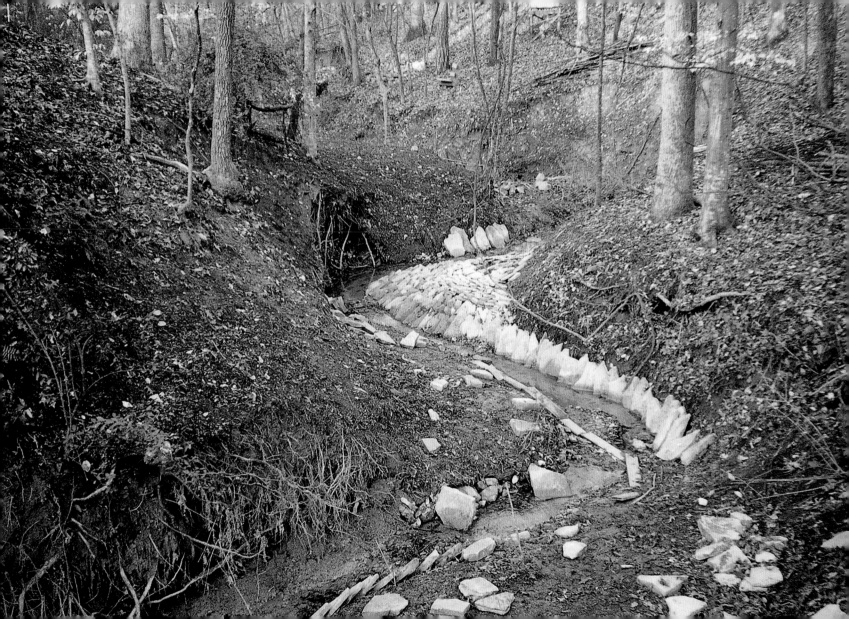

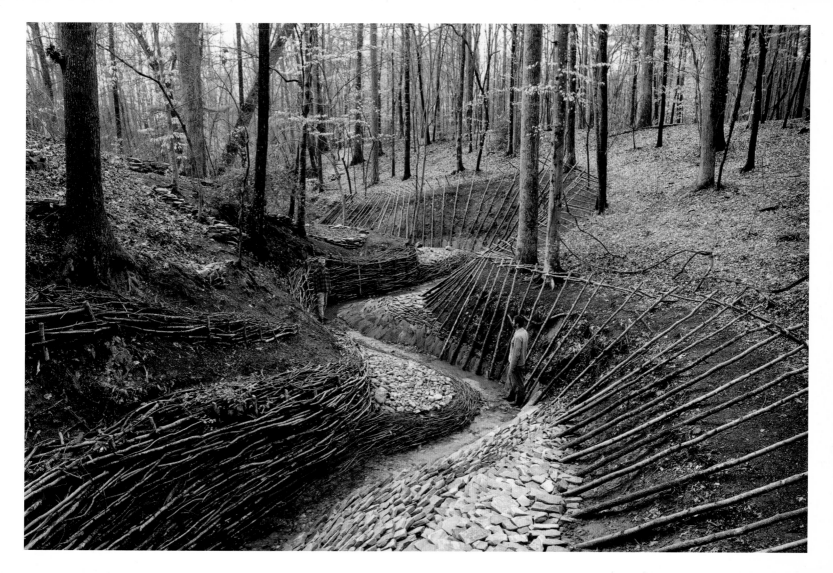

Size: approximately 98 feet long, 5 feet wide, maximum height 10 feet.
Materials: dead Picea abies, Picea abies cones, dead boughs and branches of Picea abies, dead leaves, Avellana branches, wire, stones, horticultural protective netting, Picea abies plantation.
Situation: a dead, fallen and uprooted spruce tree, on a slope of the Val di Sella Forest.
Timber: the trunk joins the two extremities of the tree, it is the place of circulation and passage of energy.
Light: the foliage of the tree shelters the vegetation that benefits from greater light.
Shadow: the roots pulled out of the soil open the earth which offers a hiding place, a shelter.
Process: the appeal of this situation—the image of the botanical cycle—becomes the support for a rapid, temporary, transitory action.

"Our experience in places is always that of a revelation (reciprocal, for us and for the site) to be absorbed during the time of work. We accompany a déjà-là'The bent branches that shelter the spontaneous vegetation become the skeleton of the greenhouse that conserves and amplifies the natural reproductive process with the insertion of young

pines. At the foot, the traces of the root system are reiterated with branches and dead twigs (of pine) to develop the roots anew, by resemblance, and to reinforce the form of the receptacle, the cavity. The 'gardener' metaphor (cultivation) and the opportunity of the den (the wild) are a staging of our relationships with the tree… our way of living places in a given moment."

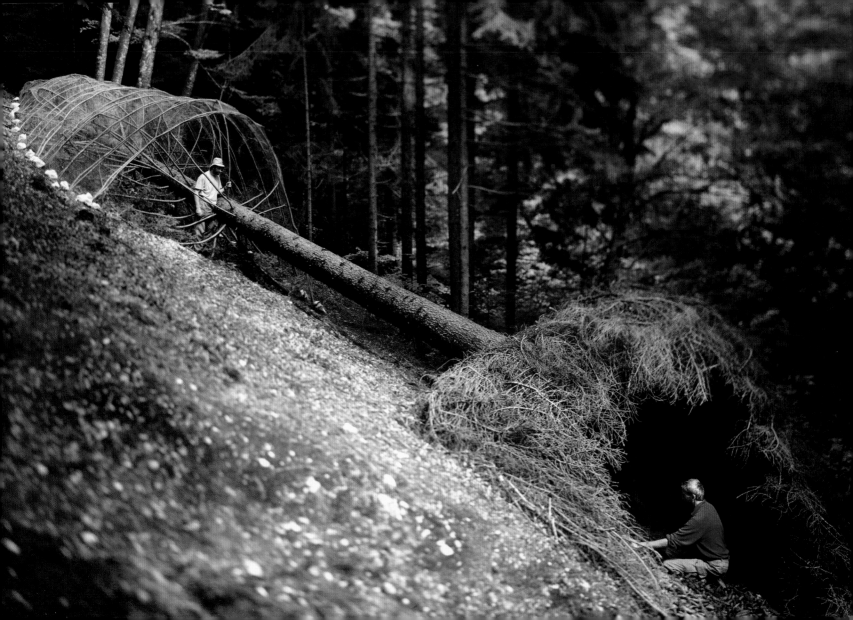

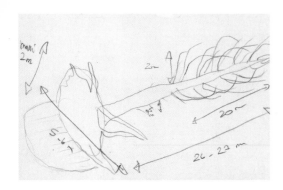

"A shared, neutral middle ground, an atelier without walls. Places should be like the frame, or the stage, for the enacting of different relations: between us, between us and others—our partners, the local populace, etc.—just as between us and the sites, which would otherwise be forgotten, abandoned. Fragments of nature, or of the countryside, that in the end were often quite close and familiar."

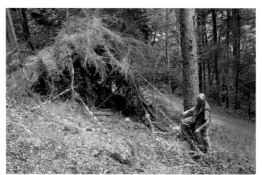

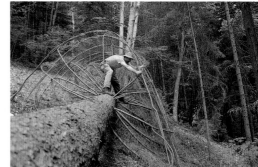

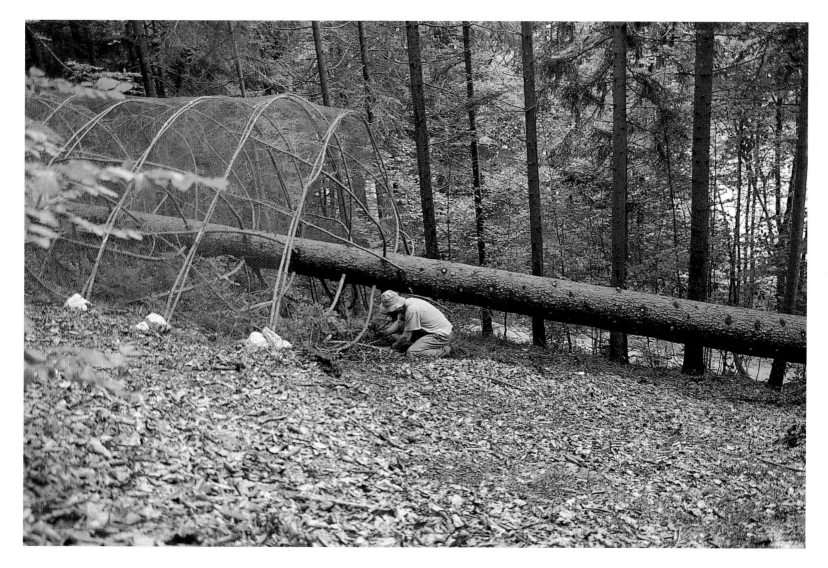

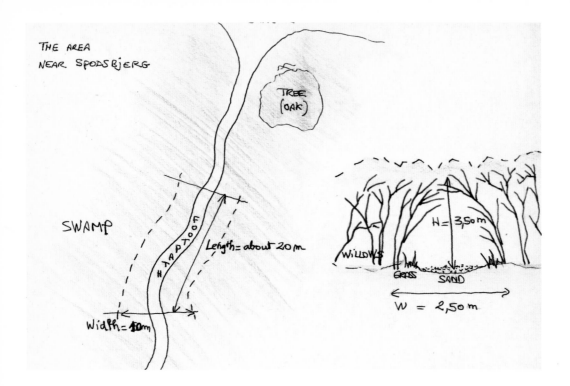

THE AREA
NEAR SPODSBJERG

TREE
(OAK)

SWAMP

FOOTPATH

Length = about 20 m

Width = 10 m

H = 3,50 m

WILLOWS

GRASS SAND

W = 2,50 m

*"Chosen in July 1995, in April of the following year the
same place had quite another appearance. The absence
of vegetation and the presence of a drainage canal
confirmed and reinforced the impression of a space
without quality... nevertheless, the closed character, and
that of connection of the path, remained. As is our habit,
we divided up the space, each taking one of the two
parts of the path, organizing and generating a shared
form, that of the 'pergola,' the two propositions related
to occupation of any public land—res communis—
assigned to themselves and to chance..."*

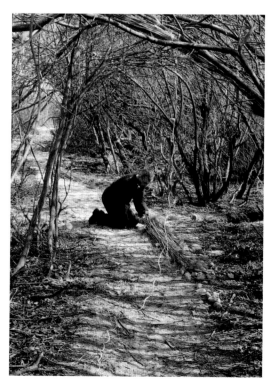

A tunnel with nature. Covering the way of our wandering Trilogi: Kunst—Natur—Videnskab, Tranekær International Center fur Kunst og Natur (Tickon), April–May 1996.

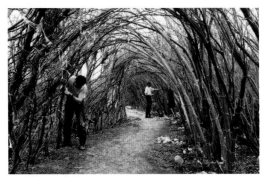

"Far from the protected, sacred places of art, 'la tonnelle' offers itself without hesitation (having eliminated the information panel) to those who frequent the beach. It is intended as a device for alteration of the gaze in paths of access and leaving the place. Its evolution is very closely connected to its reception, which necessarily passes through the sensations received, in those instants of passage from one place to another, between the village and the seashore, before its unavoidable disintegration/disappearance."

B/B, Nuaillé, May 1996

Materials: willow boughs and branches, bulrushes, sand, dead leaves and compost, stones, sisal string, salix cuttings, planting of humulus lupulus and common reeds.

Digital montages flank the views of the tunnel, shot in the two opposite directions; the two vantage points are on the borderline between the section handled by Gilles Bruni and that of Marc Babarit.

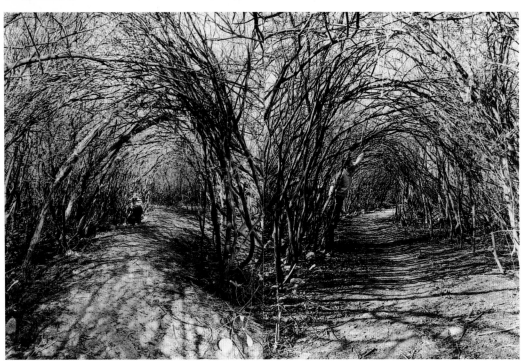

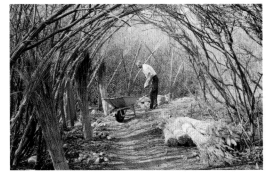

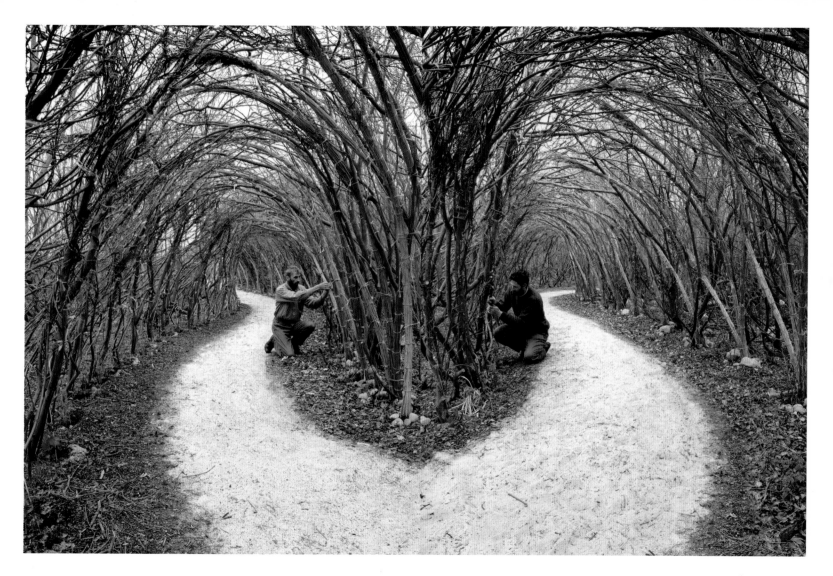

MIKAEL HA

NSEN

Unfamiliar with how one attacks the great open spaces,
I started by planting a single pole vertically in the flat
landscape. This simple action was surprisingly effective,
and is, I suppose, the essence of all our endeavors
(it can be compared to the signal of the cairn—that
a human being has been here: I have been here,
therefore I exist).

–M. H.

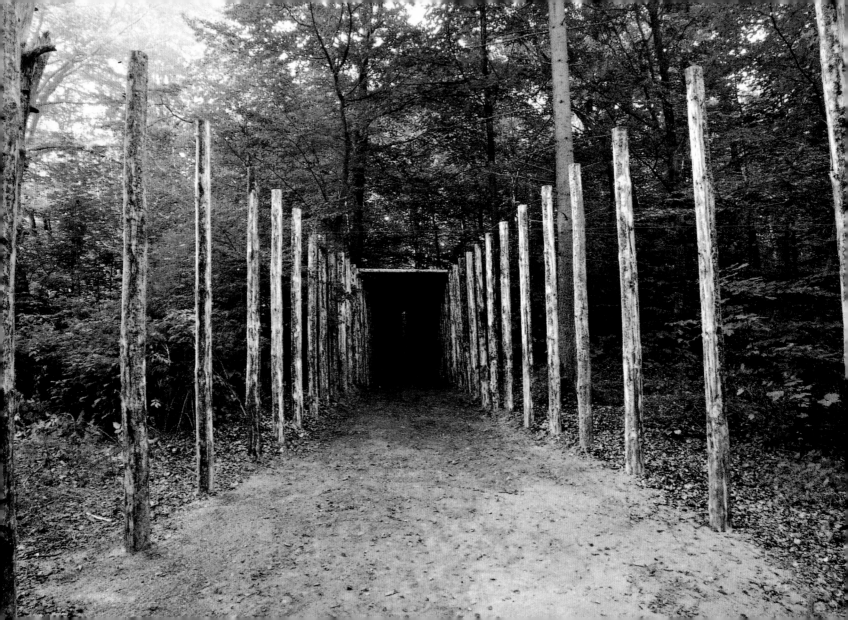

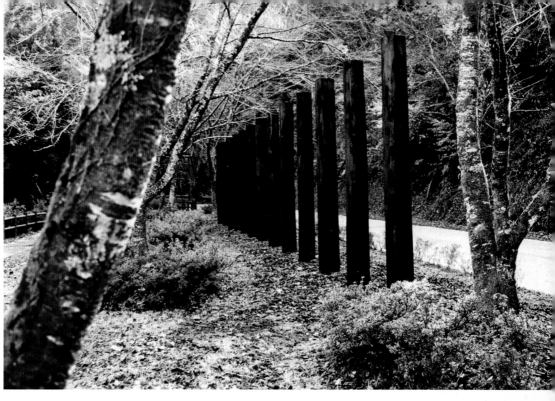

Burned Horizontal Verticals Tosa-cho, Shikoku, Japan, 1999.

Thirteen large cedar logs with the bark removed, 11.5 feet in height, are lined up along the side of the road. The charred black trunks are in a row, all of exactly the same height, all at exactly the same distance from their neighbors, and solidly planted in the terrain.

Back to Nature Artcentre, Silkeborg Bad, Denmark, 1999.

Red spruce logs found on site, charred by fire and lined up in a fence that extends from the forest to close in a wedge. At the vanishing point of the wedge there is a dark room, partially covered, with a narrow opening offering a view of "wild" nature.

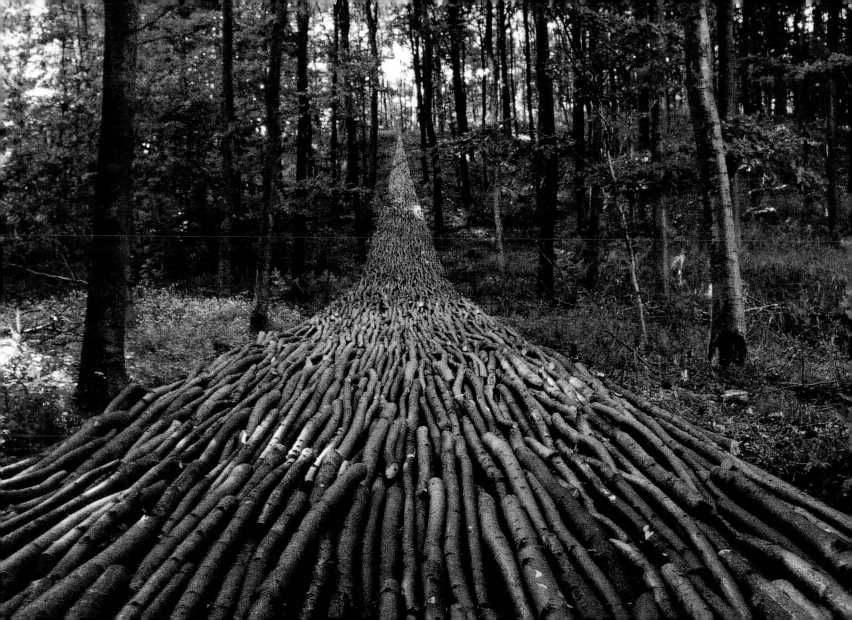

A band, 197 feet long, formed by sycamore branches and placed on a forest-covered slope. The poles were cut, in the forest, during thinning operations, and then placed on the ground to form a road leading straight to the top of the hill. At its lowest point the width is 11.5 feet, and the path tapers gradually on its way to the summit, where the edge of the hill coincides with the horizon. The false perspective of the organic motorway seems to increase the depth of the landscape, an effect landscape architecture has been employing for centuries.

Organic Highway Tickon Skulturpark, Langeland, Denmark, 1995.

Green Space, 200 mq of one-way structure Vestskoven, Albertslund, Denmark, 1995. Preliminary study for the Organic Motorway.

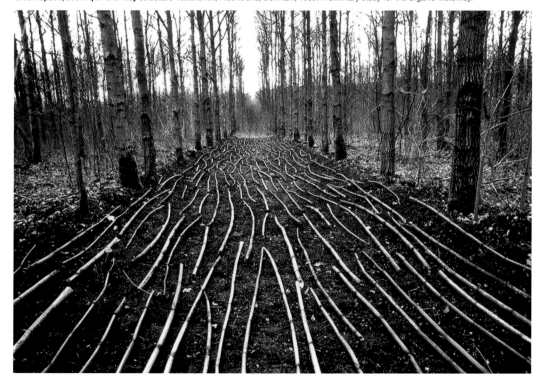

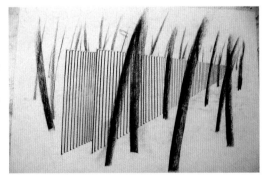

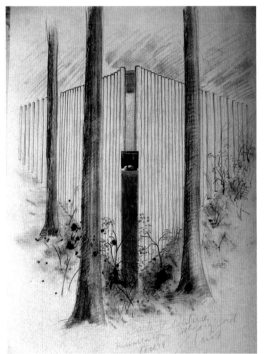

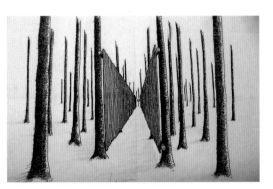

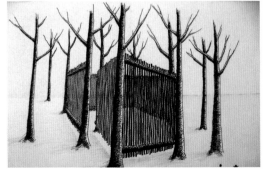

Site Specific Installation for the People of Isegawa Tosa-cho, Shikoku, Japan, 1998.

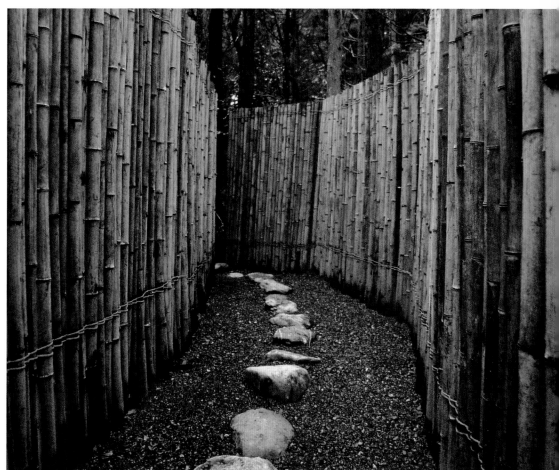

The *Site Specific Installation for the People of Isegawa* is located in a small forest of cedar, bamboo, palms and vines, surrounded by rice fields. A small stream flows nearby, out of the mountain. Hansen has chosen a clearing amidst eight cedars and built a bamboo room terminating in an acute angle and open on the opposite side. The walls are formed by 327 bamboo canes, each 6.5 feet in height, attached to a horizontal bar. The humid ground is covered with gravel and the surrounding area is arranged as a carpet of branches pointing toward the walls of the room. Hansen wanted to create a place where people would feel safe; a place of peace, halfway between an exterior and an interior.

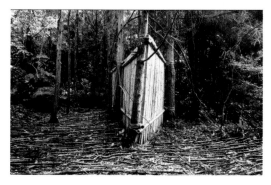

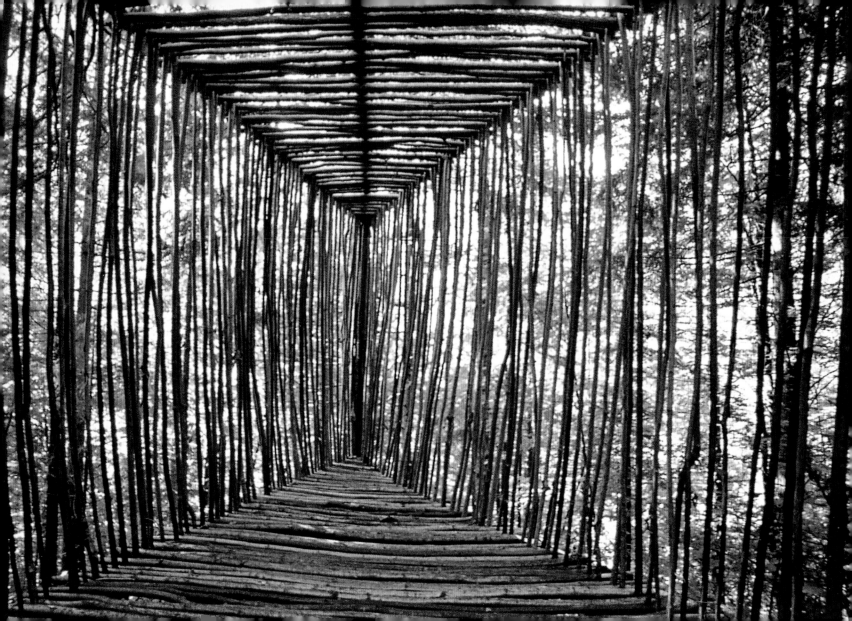

The Wall. Installation for Citizens Arte Sella, Borgo Valsugana, Italy, 1994.

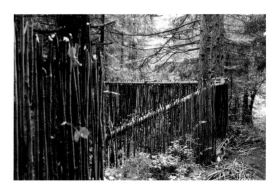

The fence of logs and branches extends for about 99 feet through a wooded slope. In the central part the wall becomes a covered room perched on the slope of the mountain.

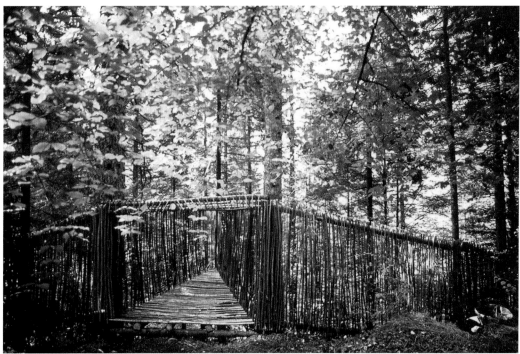

GIULIANO I

MAURI

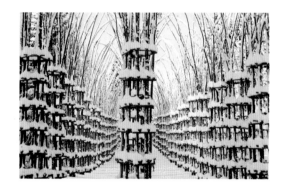

Inside these structures there will be hornbeam plants. I construct frameworks to accompany the plants in the twenty years they require to reach maturity. After this time the structures are destined to rot, to become earth. In the end the columns will no longer exist. Over the years the artifices constructed to accompany the growth of the plants will rot and leave all the space for the eighty living hornbeams that form the true botanical cathedral: then nature will have taken over. But the dialogue with man will remain indelible, a trace nature will not forget.

–G. M.

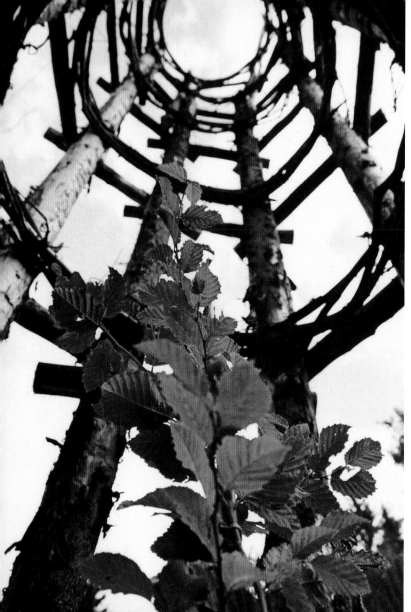

Botanical Cathedral Arte Sella, Borgo Valsugana, Italy, 2001.

After thirty years of planning, Giuliano Mauri has been able to execute a work in which he feels his principles of close, full collaboration with nature are fully represented.
The *Botanical Cathedral*, the most important project in the 2001 edition of Arte Sella, is located near Malga Costa and has the size of a true Gothic cathedral. It is composed of three naves formed by eighty columns of woven branches. Each column is twelve meters high by a diameter of one meter. A young hornbeam has been placed inside each column. The plants will grow about twenty inches each year, and by cutting and pruning they will be trained to form a true *Botanical Cathedral*. As a whole, the structure rests on a rectangular base measuring 269 x 29 feet, with a height of 40 feet. It covers an area of 4035 square feet.

"I am a part-time sculptor; the other half of the time, the other half of the work, is done by nature."

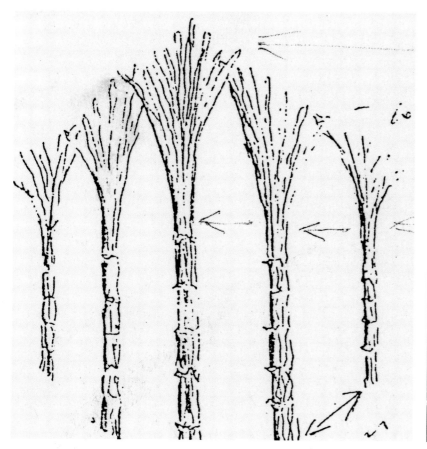

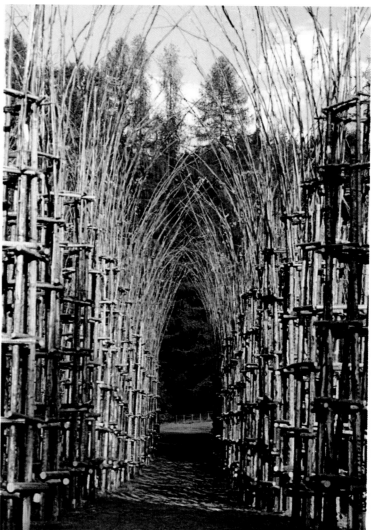

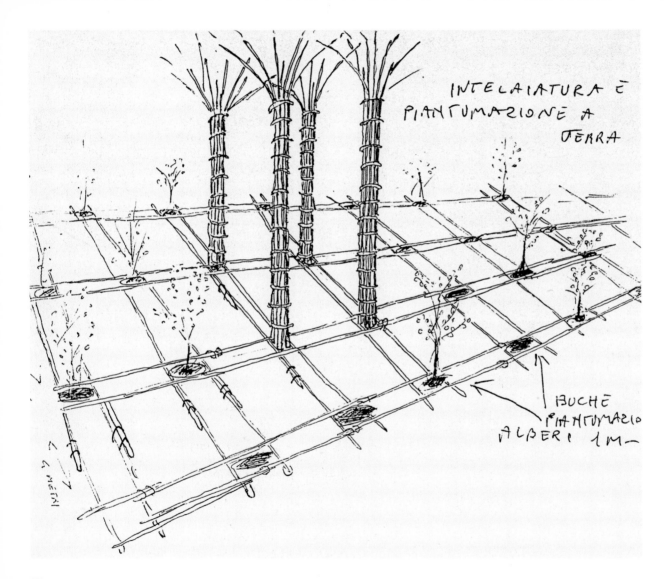

INTELAIATURA E
PIANTUMAZIONE A
TERRA

BUCHE
PIANTUMAZIO
ALBERI 1M—

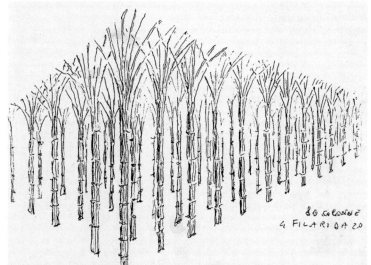

80 COLONNE
4 FILARI DA 20

"The column keeps the young tree sturdy and firmly in place. The plant grows in good health, protected by the column, for twenty years: after that, the artificial part vanishes, and there will be only the eighty living trees of the botanical cathedral."

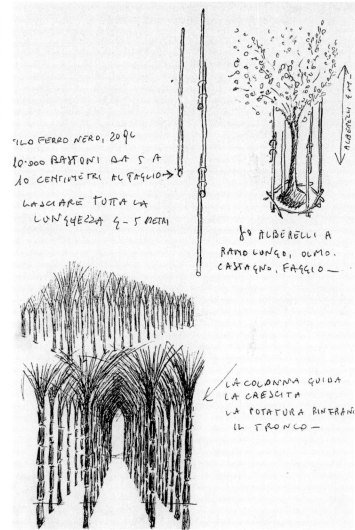

FILO FERRO NERO, 20 QL

10.000 BASTONI DA 5 A
10 CENTIMETRI AL TAGLIO →

LASCIARE TUTTA LA
LUNGHEZZA 4 - 5 METRI

ALBERELLI 6 MT

80 ALBERELLI A
RAMO LUNGO, OLMO.
CASTAGNO, FAGGIO —

LA COLONNA GUIDA
LA CRESCITA
LA POTATURA RINFRAN
IL TRONCO —

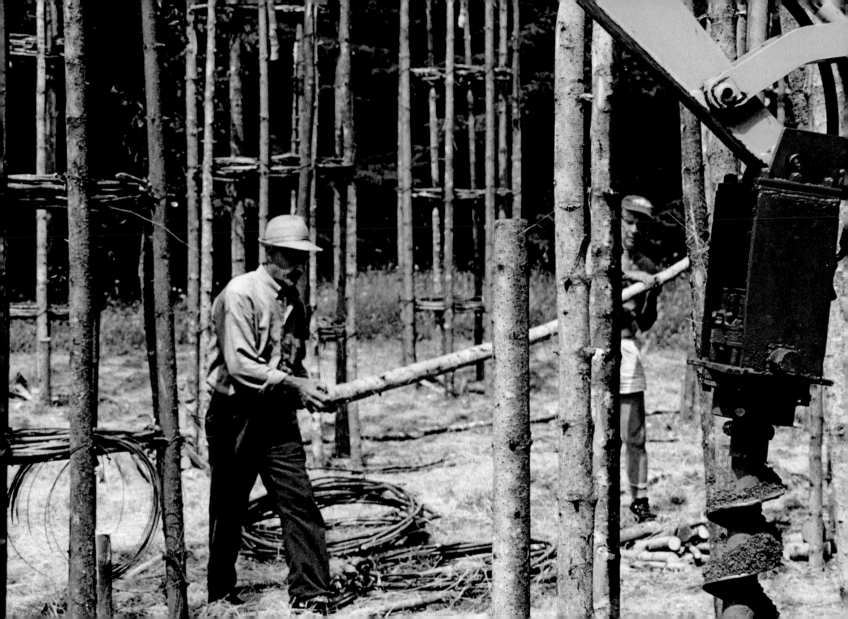

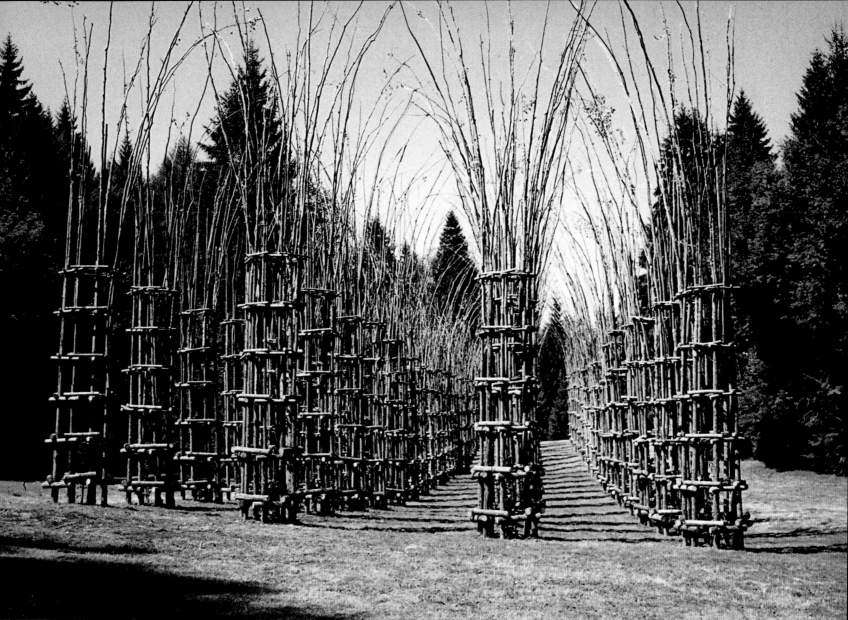

The town is emptying: of the 5000 inhabitants of a few years ago, only about 300 remain. A population drain the workshop conducted by Giuliano Mauri attempted to counter by means of a process of sowing and rebirth, projected toward the future. The artist, in collaboration with the inhabitants, builds three rafts formed by a deck filled with earth and covered with a chestnut-wood trellis. Allowed to drift in the artificial lake, the earth contained in the framework will be sown with the seeds of the plants and trees that grow there. We cannot know where or when, but sooner or later their roots will attach themselves to the lake bed, and the migration will have come to an end.

Migrating Rafts Laboratorio d'arte, Gallo Matese (Caserta), Italy, 2005.

 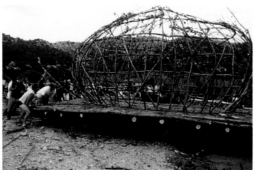 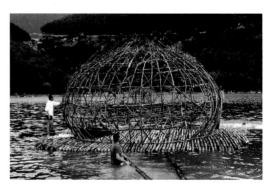

The three rafts are made of chestnut wood. Two have a diameter of 33 feet, while the third, smaller raft has a diameter of 26 feet.

The installation is composed of two gigantic spyglasses in chestnut and oak, positioned on the two sides of the border between Germany and Poland. The Neisse River divides the city in two; it is called Görlitz on the German side and Sgorzelec on the Polish side. The identical spyglasses stand on the two banks, where there was once a bridge. The viewing end of the spyglass has a diameter of 4 inches, while the opening facing toward the opposite bank has a diameter of 16 feet. The entire structure of each spyglass has a length of 66 feet.

Estimatory Spyglasses Görlitz (Germany) and Sgorzelec (Poland), 2001.

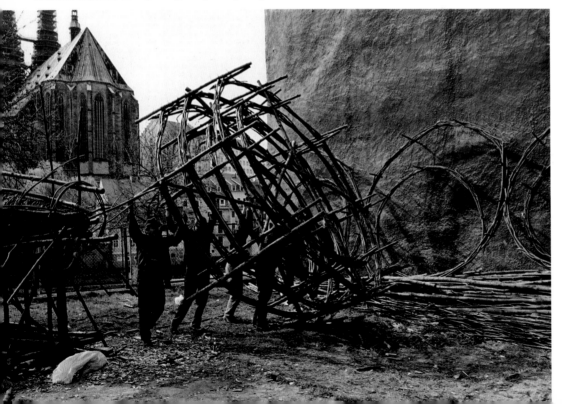

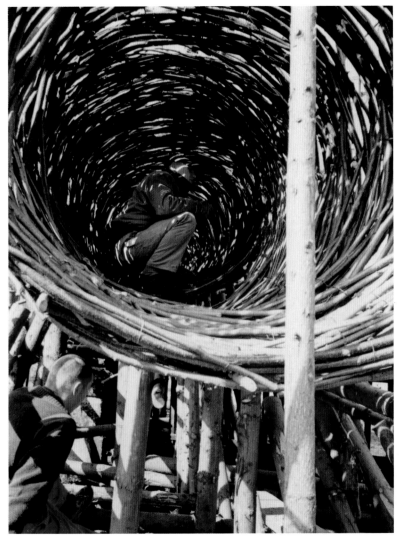
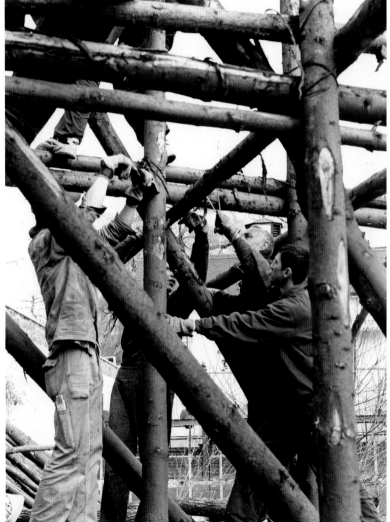

"The two spyglasses form a visual, ideal bridge between two peoples that seem to be divided by hatred.
This is a more direct, neutral means of communication than the media, which encourage, separation every day, blinding reason with ideology."

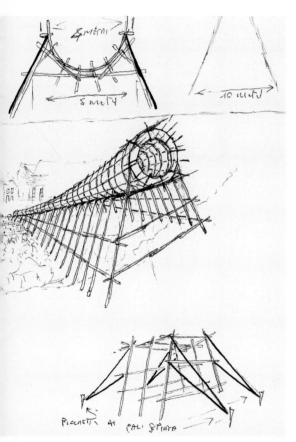

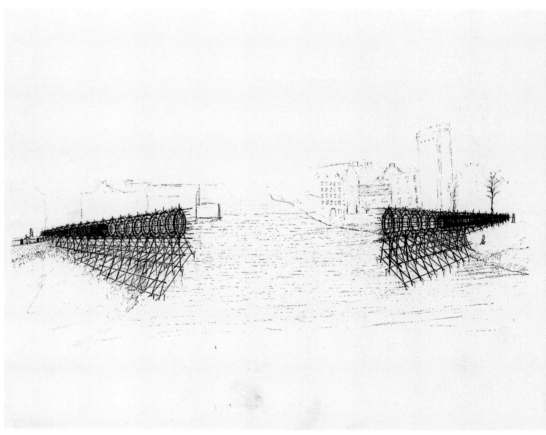

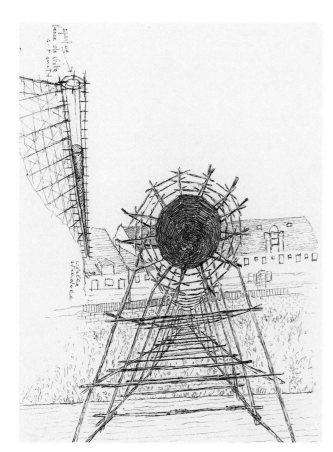

"Two spyglasses looking across the border, to observe each other in a different way."

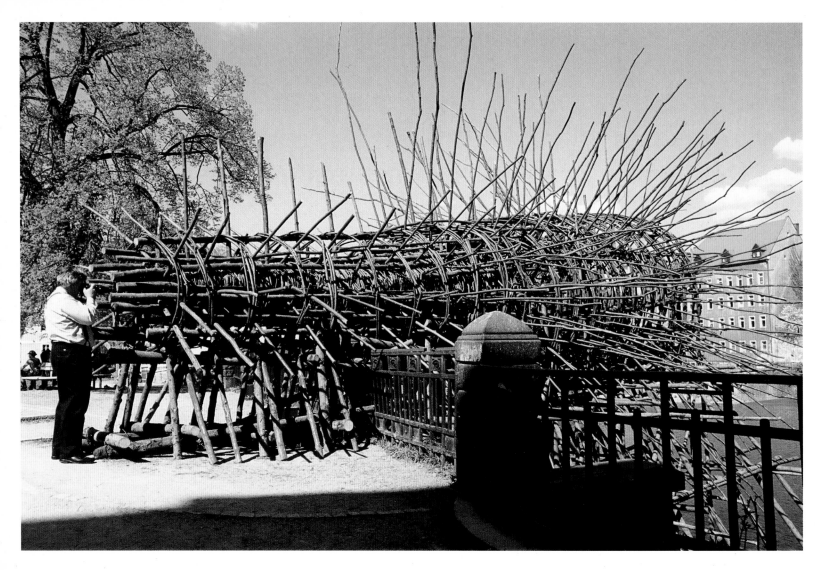

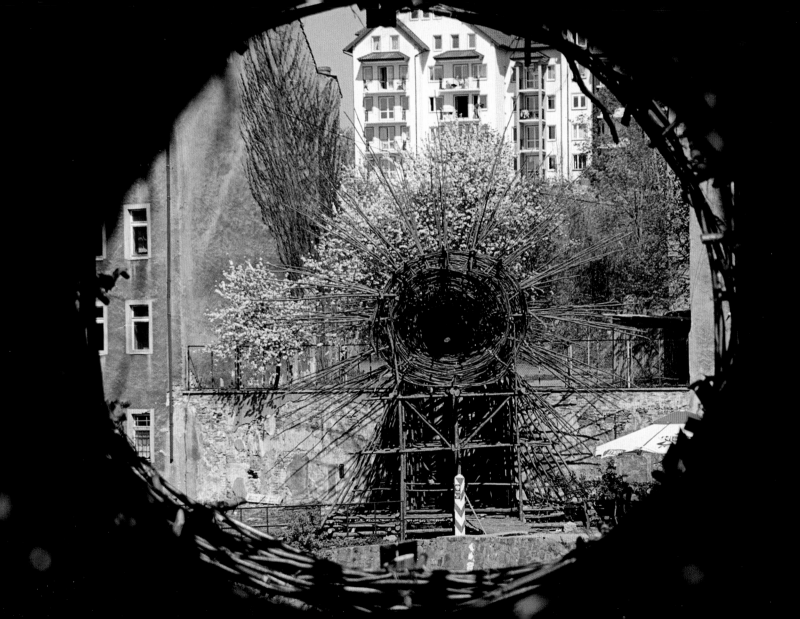

SANFTE ST

RUKTUREN

*The difference between the house and the garden
disappears; the mason and the gardener become
the same person.*

–Marcel Kalberer

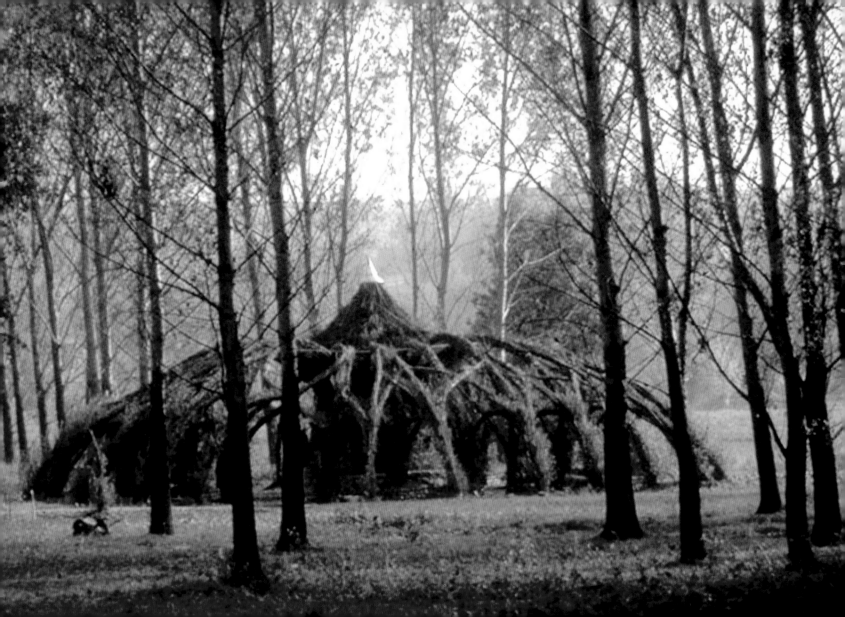

Auerworld Palace Weimar, Germany, 1998.

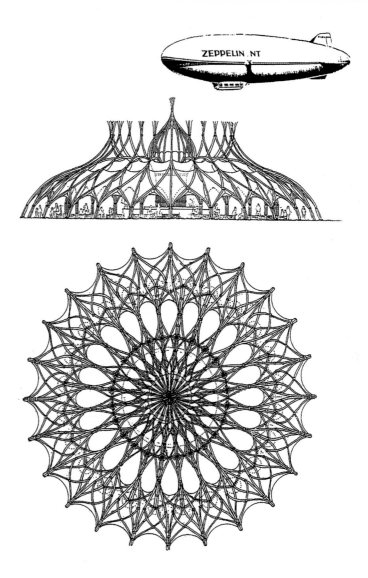

The *Auerworld Palace* was built in March–April 1998 thanks to the collaboration of 300 volunteers from all over the world. The way in which it was "planted" illustrates the energy potential that can be developed in a process of natural growth conducted within a community project. Marcel Kalberer worked with the group of builders and artists Sanfte Strukturen, who organized the project. The construction was an event of social value and the Palace then functioned as a catalyst for community celebrations. The full moon events, for example, have attracted over 80,000 people. The *Auerworld* is the first palace made with the live willow system. It has become a tourist attraction for the region between Weimar and Naumburg. Marcel Kalberer with Sanfte Strukturen (Bernadette Mercx, Dorothea Kalb-Brenek, Eugen Lüdi, Therese Vögtlin, Jacky Roland, Philippe Rohner). Commissioned by: Weimar 99, Weimarer Land Förderverein Auerstedt.

1999

2002

2005

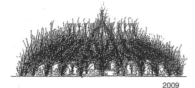

2009

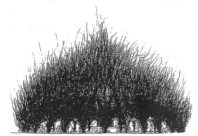

2012

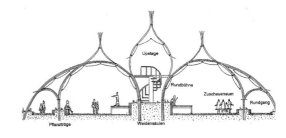

The main source of inspiration, for Marcel Kalberer, is the Mudhif, the very ancient technique of construction with reeds, regularly utilized in Mesopotamia for over 5000 years. The Mudhif is the traditional dwelling of the people of Madan, in the swamps of southern Iraq. The Mudhif house is made from the reeds that grow in the swamp.

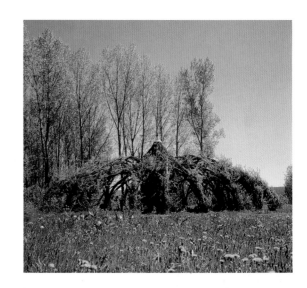

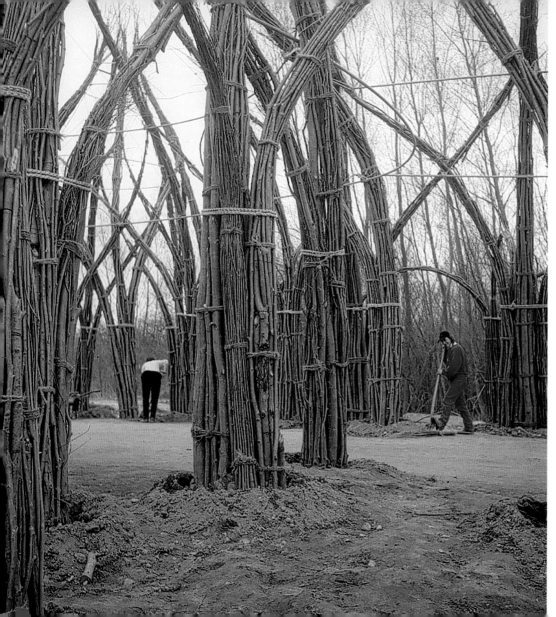

Weidendom Rostock, Germany, 2001.

The willow cathedral was built in two months, at the start of spring 2001, with 600 volunteers from 12 different countries. Every day a squad of fifty to seventy people worked under the guidance of Marcel Kalberer and with the assistance of Sanfte Strukturen. The plan of the structure is based on the model of the basilica, with naves, cupola and apses. The shipment, requiring thirty trucks of from 2300 to 2950 cubic feet of willow branches and logs was trimmed on site and attached around a slender steel trellis. Arches with a span of 30 feet, with a diameter of 20 inches at the base and 4 inches at the top, for a total weight of 6.6 tons, were raised with human power only by the volunteers. The bundles are planted in the ground at a depth of one meter. The cathedral was utilized by the ecumenical Christian churches and the Jewish community during the International Garden Exhibition of Rostock in 2003. The space of the church has been protected with tarps stretched over the living willow construction. The living structure symbolizes the living church and looks forward to a new link between nature and the sacred dimension.

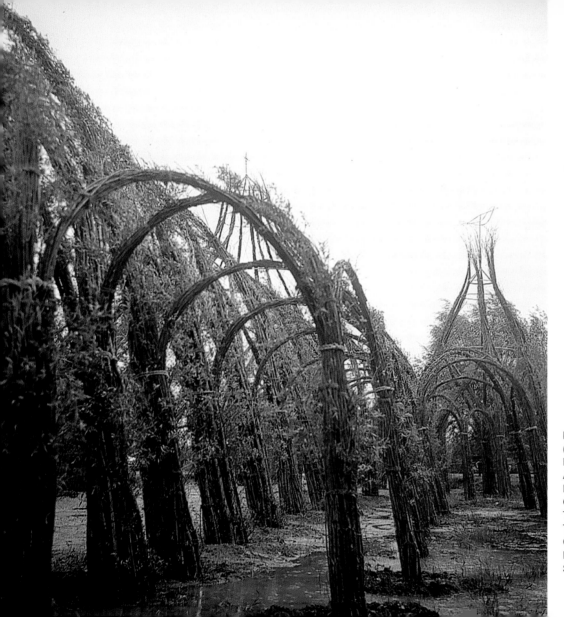

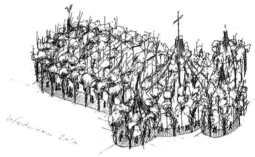

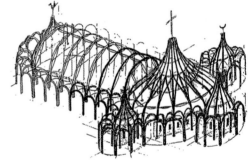

Marcel Kalberer with Sanfte Strukturen
(Bernadette Mercx, Dorothea Kalb-Brenek,
Eugen Lüdi, Jacky Roland, Philippe Rohner,
Anna Kalberer, Dominique Kunz, Toni Anderfuhren,
Karin Ranneburger, Michel Kussl, Birgit Weiden,
Gabi Hüttl, Sofie De Baerdemaeker, Cécile Baud,
Tanja Georgieva, Raul Böhm, Adrian Schneider,
Therese Vögtlin, Karin Krembs, Tobias Krause).
Commissioned by: Ecumenical Churches from
Mecklenburg - Vorpommmern,
Schwerin IGA 2003, Rostock, Germany.

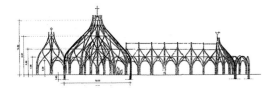

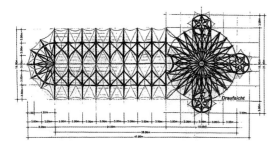

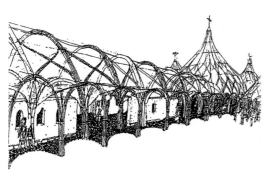

The willow branches combine in arches that construct an edifice formed by a single natural structure. The willows, planted in the ground and supported by a light steel framework, take root. Over time their growth completes the architectural design of the building.

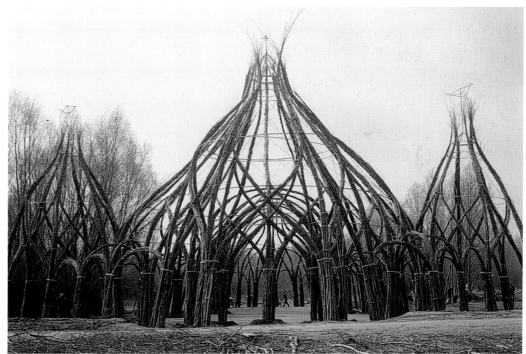

Weidenarena Cologne, Germany, 2002.

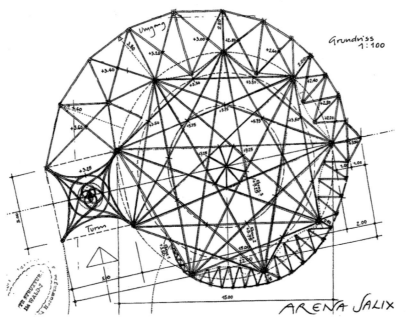

Grundriss
1:100

ARENA SALIX

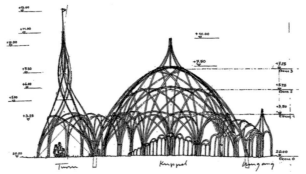

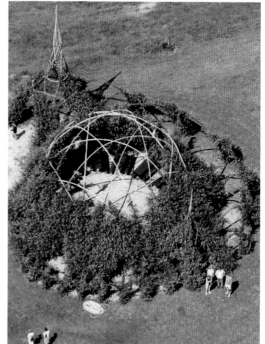

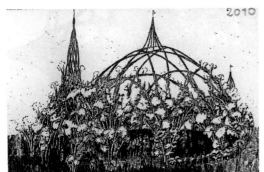

2010

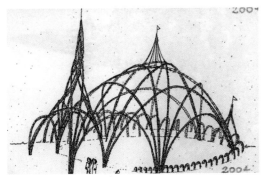

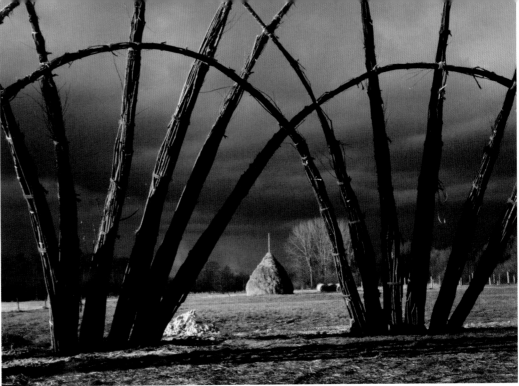

Arena Salix Schlepzig/Spreewald, Germany, 2004.

The cupola has a diameter of 50 feet and a height of 25, while the height of the tower is 36 feet. Around the cupola runs a path with a vaulted roof that begins with a height of 13 feet and gradually tapers to a 1.6-foot section, just large enough to permit a child to pass through. This was our first geodesic dome, inspired by Frei Otto and utilized by tourists who arrive by ferry, canoe, and bicycle (we are about 37 miles south of Berlin), above all to sample the special beer of this locality. On summer weekends concerts and other forms of entertainment are held here. The building belongs to the Römer family, who also own the local hotel and beer hall.

"...These structures, hybrids of tree and building, are never really completed, because they continue to grow and transform in keeping with natural growth processes..."

Operair-stage at Boizenburg Boizenburg, Germany, 2005.

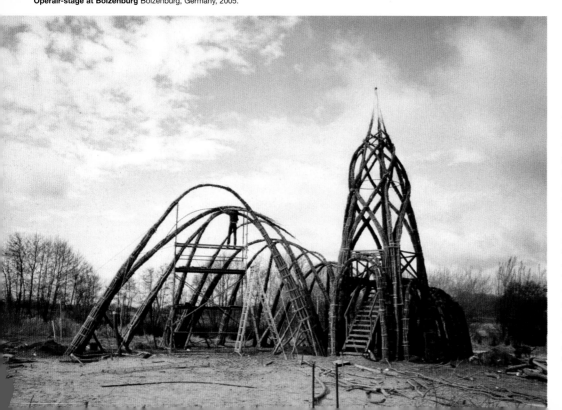

The stage is designed for different theater events and music festivals in the city of Boizenburg/Elbe, 31 miles from Hamburg. The proscenium arch has a width of 36 feet and a height of 20 feet, while the stage has an area of about 330 square feet. The scroll form permits use of the part behind the stage for backstage facilities. The tower has a height of 36 feet and the audience can access the platform, at a height of 13 feet. From the city to the outdoor theater site a pedestrian walkway has been created, 1640 feet long, featuring over 200 willow sculptures whose 15 different forms represent 15 musical instruments of the orchestra. The tallest sculptures represent the higher notes, while the width of the trail indicates the sound intensity, and the distance between one instrument and the next represents the duration of the sound. The composition was developed especially for this project by Dorle Feber, and will be played for the first time by the Boizenburg Orchestra in the Fall of 2006.

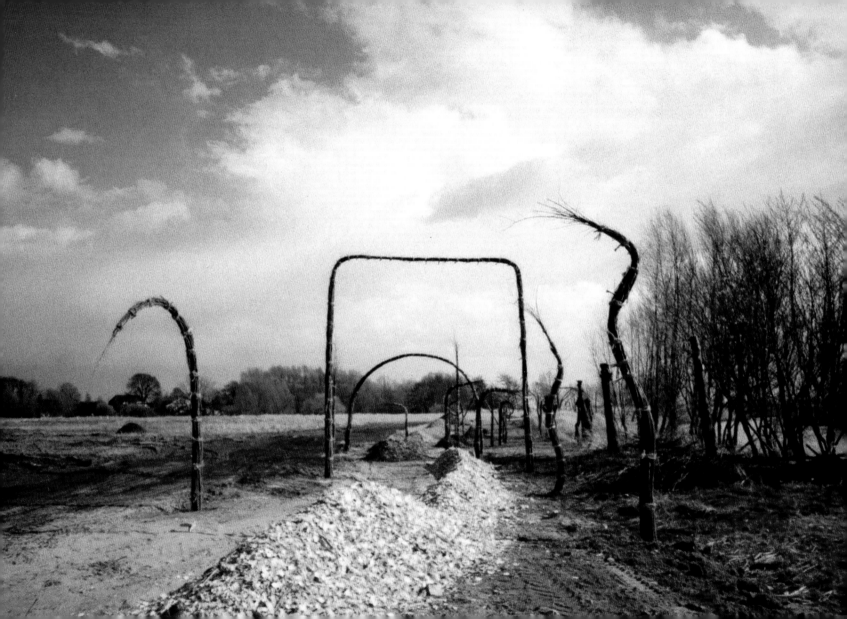

ICHI IKEDA

Working on different long-term projects that come to terms with the new multicultural reality, I have reached the conclusion that one of the means of exploration of culture should be a "water-based culture." This century is often indicated as the Age of Water, as opposed to the Age of Fire, with the wars and dramatic growth of the twentieth century. There is little doubt that a water-based culture can be the most powerful medium for those in search of new possibilities of coexistence and cooperation to span the diversities that furrow the world.

–I. I.

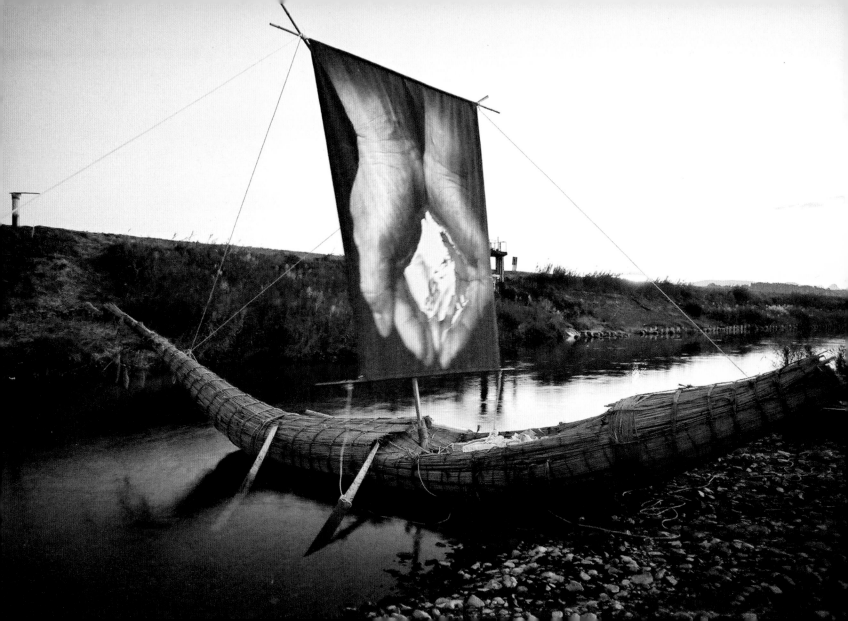

Water Ekiden Manosegawa River Art Project, Kagoshima, Japan, 1999.

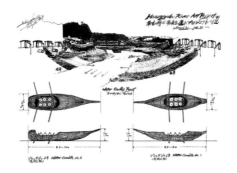 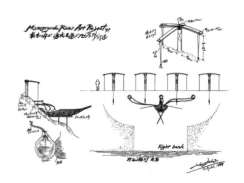

The Manosegawa is a river that runs for 16 miles through the southern part of the island of Kyushu, into the China Sea. This project involved the collaboration of four communities in the Manosegawa basin, joining forces for the first time. At the first meeting Ichi Ikeda explained: "A work of art is like a magnifying glass, it is something that permits you to see what you haven't seen before: the story inscribed in the terrain, the appearance of new images, the relationship between man and nature, etc." Starting with these processes, the artist and the people of the valley worked together for two months to construct an appreciable combination of what is called sense of community, and the sense of belonging to a shared place. The key concepts that accompanied the entire work were presented as follows: "Water Ekiden Project in alliance with the people of the basin," and "the network to produce water is essential for the future of our planet." We can compare the river to a railway, along which four stations have been built, in keeping with the different hydraulic situation of each of the four districts: water from the sky (rain), water from the ground (springs), water for everyday use (purified) and water for agriculture (irrigation). Each water station has the role of an initial destination, posing the same question for visitors: "What water will you bring to the future inhabitants of the earth?" The members of the committee of the Manosegawa River Art Project spoke of their hopes: "We hope these artworks will encourage people to look with greater interest at the problems of water and to make a more active commitment in volunteer work and community exchanges."

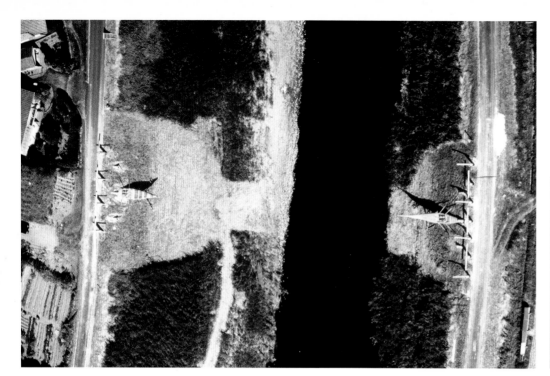

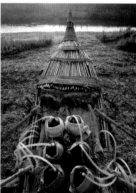

Water Station "For the Earth" Riverbank of the Manosegawa River, Kawanabe, Kagoshima.

The objective of the Station is to collect and transfer spring water. Ichi Ikeda has constructed the boat out of rushes and the remains of the bamboo boat as if they were relics of ancient times: they resemble a "Water Cradle," to convey water with care and affection. Two "Cradles" have been installed on the banks of the river, with their prows sunken in the ground to draw on the spring water.
Size: 210 x 60 x 30 feet.
Material: bamboo, reeds, wires, ropes, wooden oars, earthen pipes, boards, glass containers, hemp sacks, plastic hoses, screen with image of "Big Hand."
Photos by Tatsuro Kodama.

Water Station "For the Heaven" Former site of Water Mill, Chiran, Kagoshima.

The Station is located in the territory of the community of Chiran, along the upper stretch of the river, and is formed by three "water cargo ships" created inside the ruins of three large chicken coops. The tanks collect and conserve rain water with the aim of transferring it to the arid zones where the earth suffers from drought. Total size: 75 x 72 x 21 feet, size of a water cargo: 19 x 65 x 9.5 feet.
Material: broken hen-breeding houses, woods, blocks, ropes, bamboos, poles for scooping water, chairs, photos, sand, water.
Photos by Tatsuro Kodama.

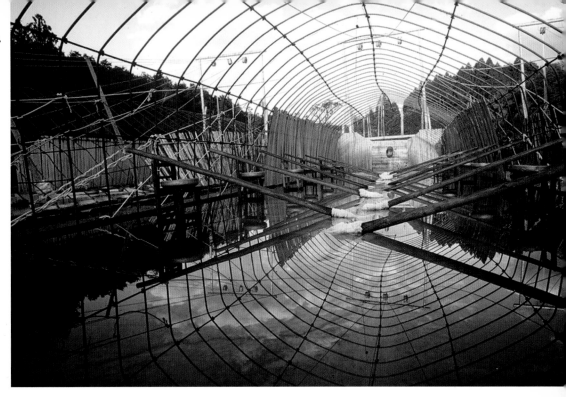

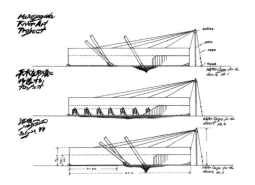

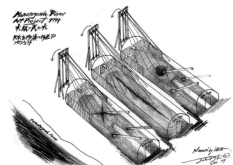

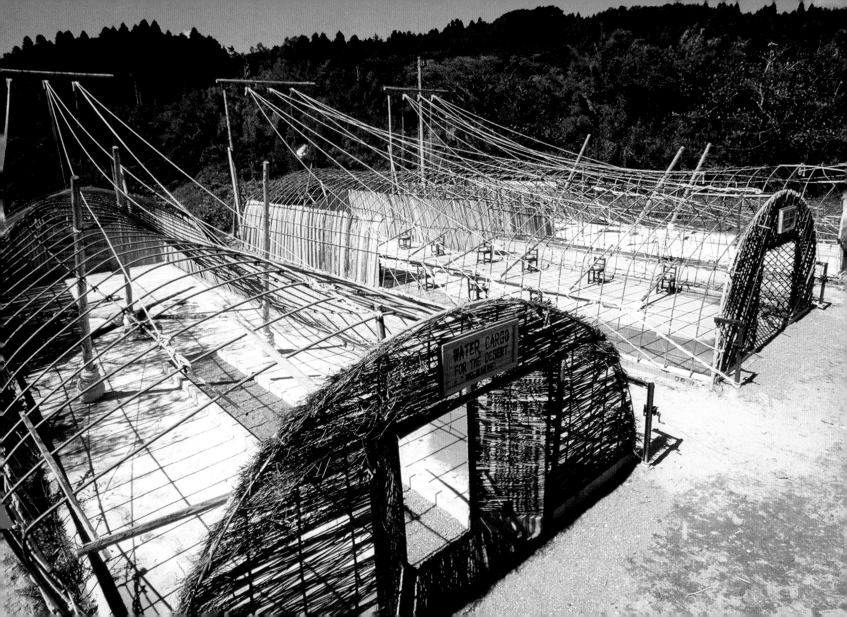

Water Station "For the Human" Irrigation canal, Kinpo, Kagoshima.

The Kinpo region is well-cultivated, and the network of canals fed by the Manosegawa is organized around the rice fields. After the rice harvest, the Station was built so that the straw fences would include the canals. In case of a particularly abundant rice harvest, the Station expands in all directions, connecting the Joint Houses, constructions that link earth and water.
Size: 246 x 246 x 16 feet.
Material: bamboo, straws, boards, plaster, vinyl tubes, chairs, benches, containers, tubs, iron, water, lights.
Photos by Tatsuro Kodama

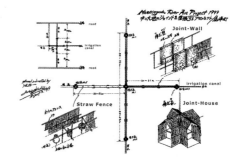

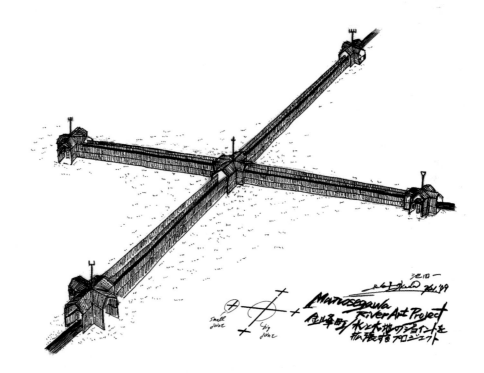

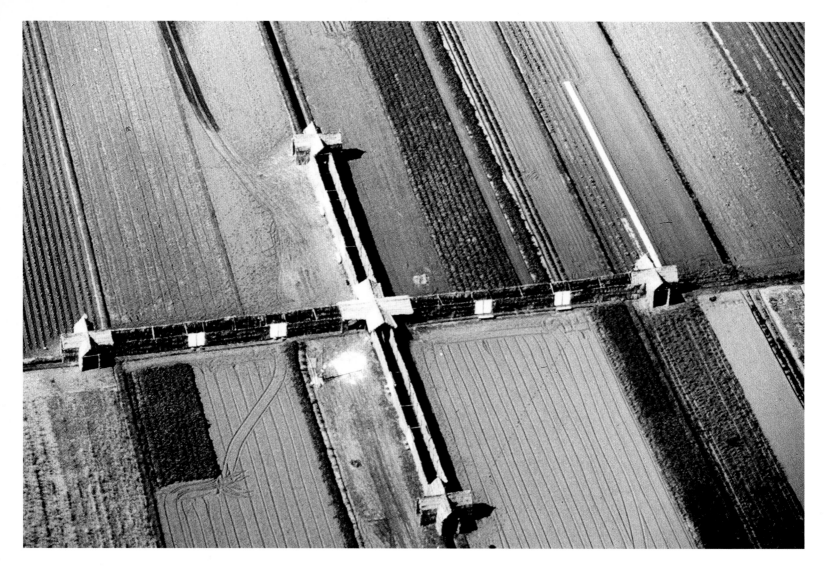

To improve connections between earth and water in all directions, the Station is organized in three fundamental structures: the straw fences, the Joint House that extends the fences in four directions, and the Joint Wall that holds the straw fences together.

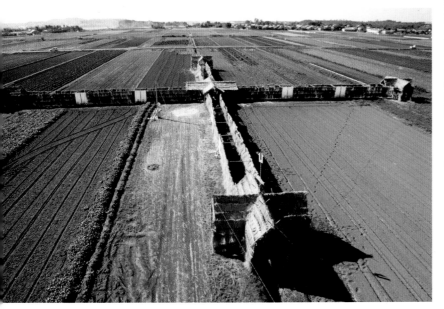

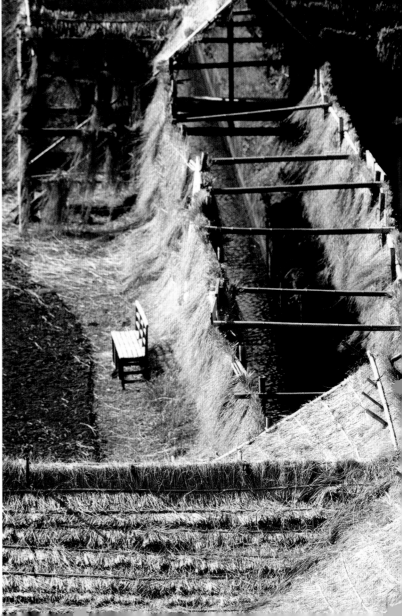

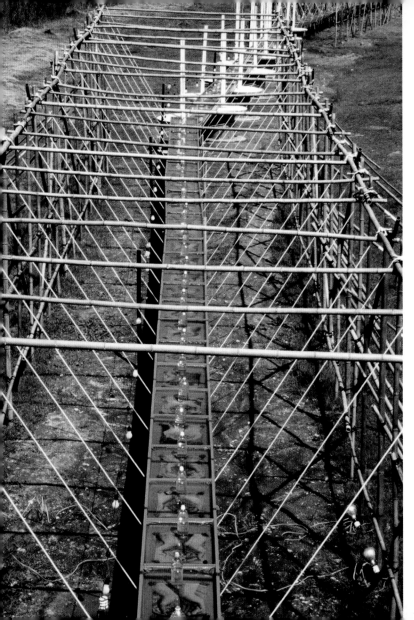

Water station "For the Water" Former riverbed of Kaseda River, Kaseda, Kagoshima.

The project extends the purified water conduit, which, running along the bed of the Kaseda, is formed by the union of 160 water containers. Inside each tub there is a photograph of hands offering water. The line of water lengthens in proportion to the growth of participation in the solidarity program of the "water sender agreement." Size: 524 x 16 x 14 feet.
Material: bamboo, water kits, loads of water (wood + copper), photos of the Water Senders, Water Sender Agreement, PET bottles, cable reels, air pumps, timers, lights.

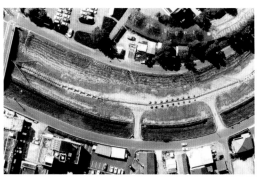

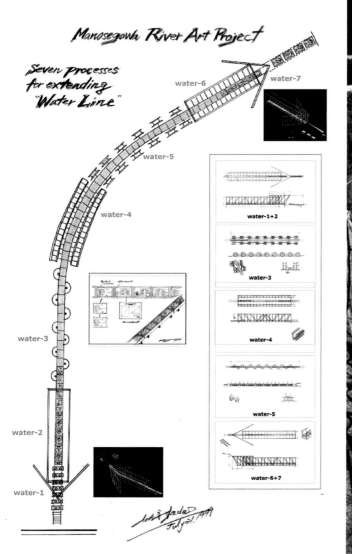

Manosegawa River Art Project

Seven processes for extending "Water Line"

water-6

water-7

water-5

water-4

water-3

water-2

water-1

water-1+2

water-3

water-4

water-5

water-6+7

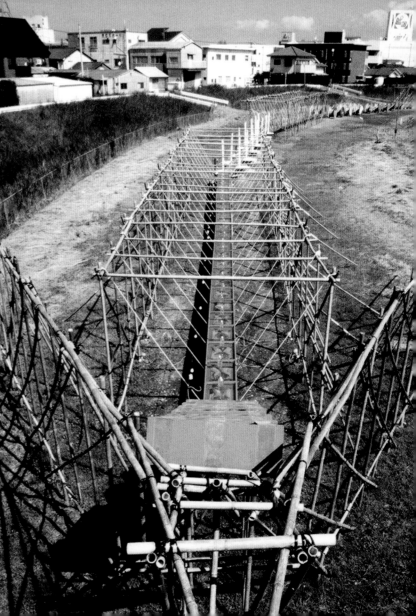

JACKIE BR

OOKNER

My living sculptures, called biosculptures, are evocative, plant based systems that clean polluted water, integrating ecological revitalization with the conceptual, metaphoric and aesthetic capacities of sculpture. These projects raise community awareness of the urgency of restoring health to aquatic ecosystems, encourage the necessary imagining of a world where human and non-human systems are mutually beneficial, and help create the public will to protect and restore these resources.

–J. B.

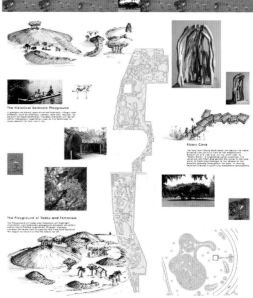

In 2003–04 the administration of West Palm Beach transformed the 130 acres of Dreher Park, the city's most important park, to increase collection of rainwater and improve the recreational facilities. The team of Jackie Brookner and Angelo Ciotti was asked to work on the design of the new park, in a role something like art direction. Following this initiative, three hectares of collection and connection basins were installed, to facilitate the water flow and guard against flooding.

The cypress swamp.

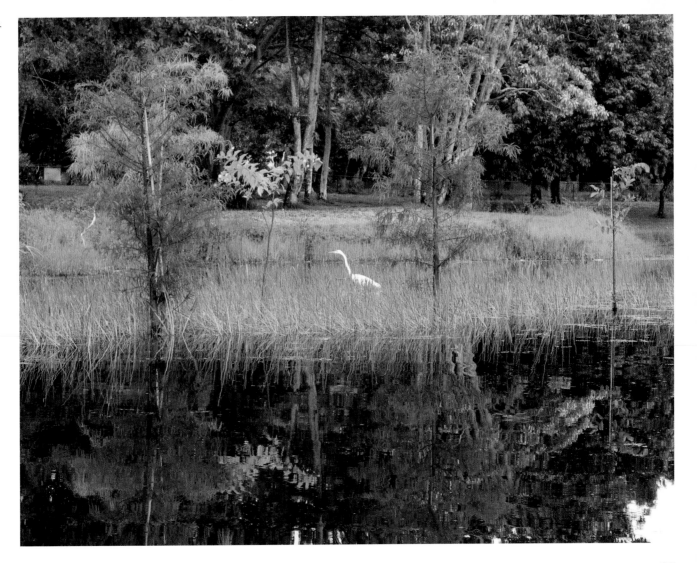

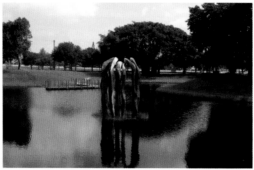

Views of the artificial lake of Elders' Cove, with the biosculpture, the banyan grove (ficus benghalensis) and the pier.

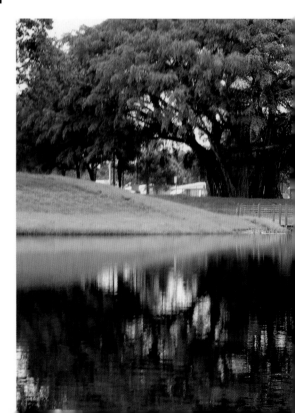

Brookner and Ciotti worked on the definition of concepts that led to the transformation of the identity of the park through the creation of new significant places based on ecological solutions. Brookner and Ciotti designed Elders' Cove, a landscape that includes the *Biosculpture*, a work 46 feet in height, colonized by aquatic plants that filter the water, a pier, wet habitats and shaped mounds that reorder the ground where excavation was done. The *Biosculpture* is based on the complex design of the banyan trunks already existing in the park. The sculpture is a living system composed of moss, swamp plants, and microorganisms that live in the roots of the plants. As a whole, this vegetation acts as a filter for the waters of the lake, which is also oxygenated by fountains, in a cycle of vaporization and condensation. In the North Lake the quality of the water and the biodiversity are improved by the marshy habitats arranged around the pier. The mounds of earth surround the playing areas, like the Choko Lochi Seminole Village, designed with the participation of Seminole Elders and containing the plants that were part of their everyday life, used to make baskets, fabrics, food, and herbal medicines. Instead of removing the existing islands, which hosted invasive species, Brookner recommended saving them and restoring them with cypress-swamp ecosystems that reproduce the marshes of the original landscape.

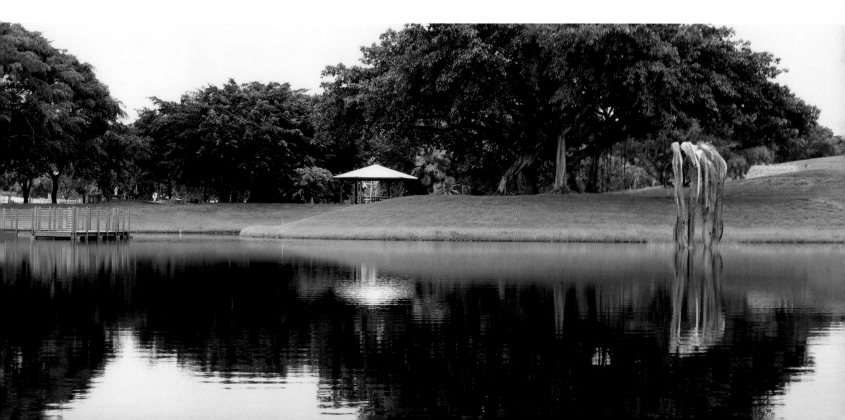

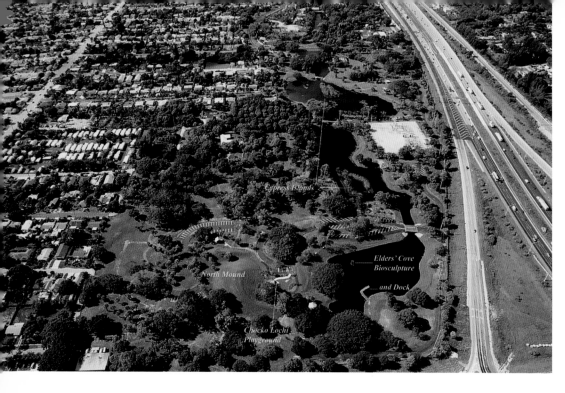

Cypress Islands

North Mound

Elders' Cove
Biosculpture

...and Dock

Chocko Lochi
Playground

Brookner's *Biosculptures*™ made
of mosses and wetland plants
growing on rocks or concrete
substrates, work according to
the principle that in nature there
is no waste. Rather, the "waste"
of one creature becomes food
and resources for another. These
are living sculptures, sculpted
wetland ecosystems, that clean
polluted water. As water flows
over the biosculpture, the
mosses, ferns, and other plants
and their associated bacteria
transform pollutants in the water
into food for their own
metabolism.

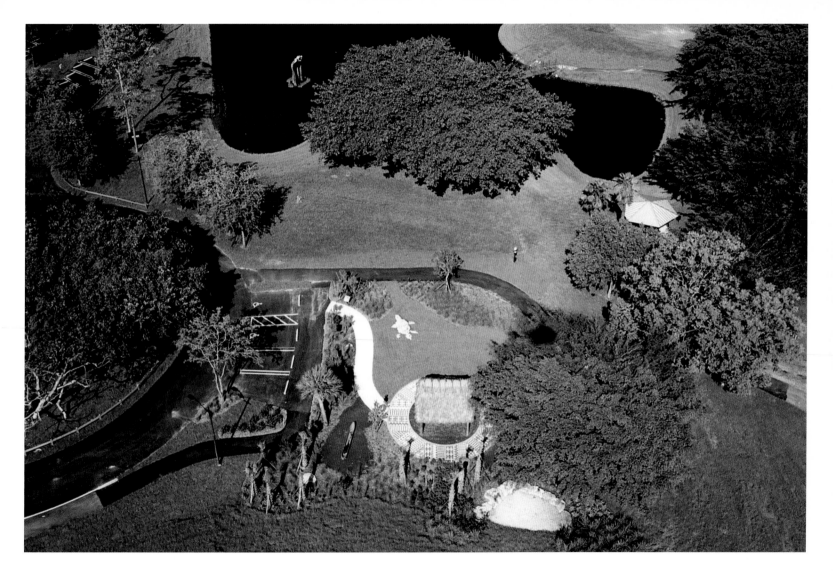

YUTAKA KO

BAYASHI

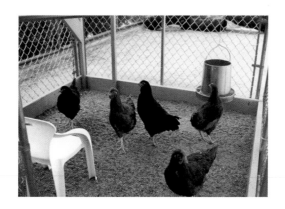

These projects for environmental education introduce people to understanding the biological cycle through the production of a real experience, aimed at schools and local communities. The method can be easily transferred and applied to everyday life, encouraging citizens to take greater responsibility for the environment and to develop networks of connections among educators, students, and citizens.

–Y. K.

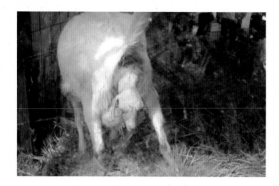
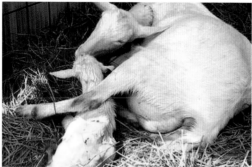
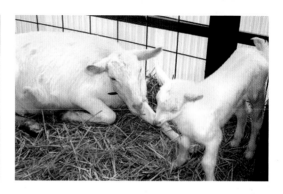

Goat House Art Network Matsudai Elementary School, Higashikubiki-gun, Niigata Prefecture, Japan, 2003.

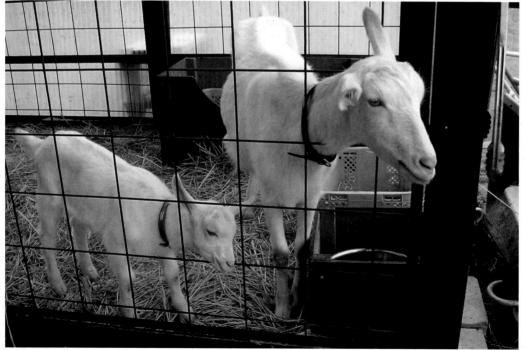

The goat house is a workshop for the students of Matsudai of the larger project *Locating Memories*. The aim is to create positive memories and supply an ecological education to improve environmental awareness. The children take part in the everyday life of the animals and their lifecycle: feeding, milking, reproduction.

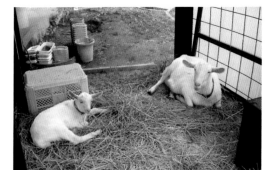
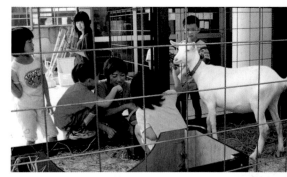
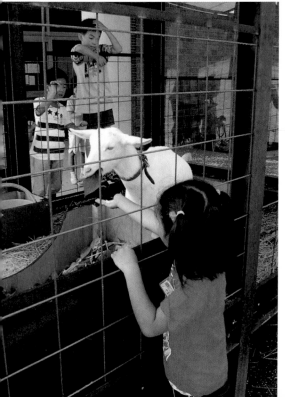
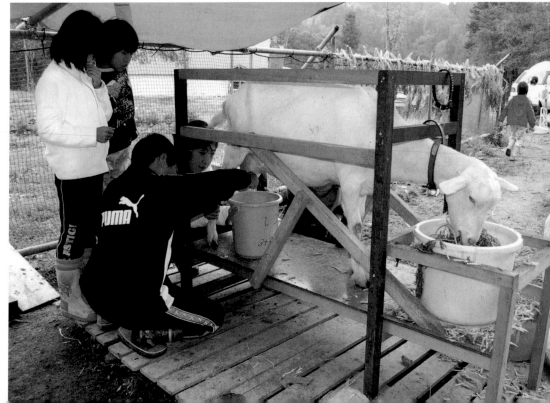

Different moments of school life around the stall:
night, class workshop, winter and summer,
with the goat grazing on the small patch of land
available to the school.

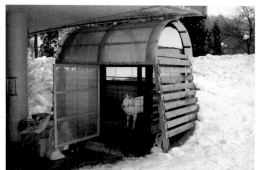

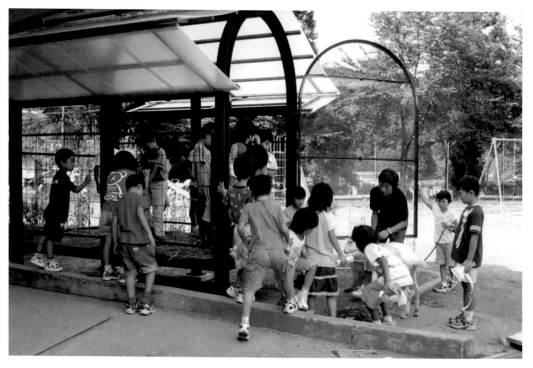

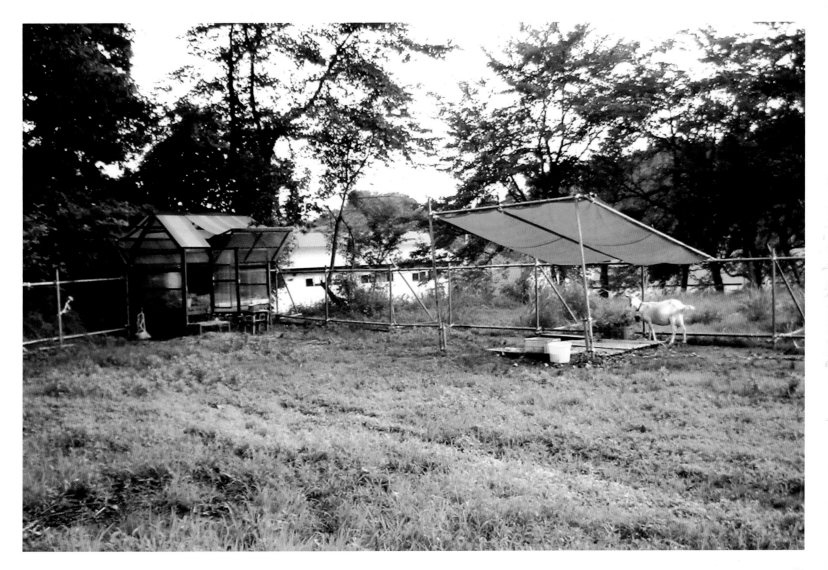

Chicken House And Eco-Art Project Arts Far West public school, Oakland, California; Terashima Daiich, Tokyo, 2002.

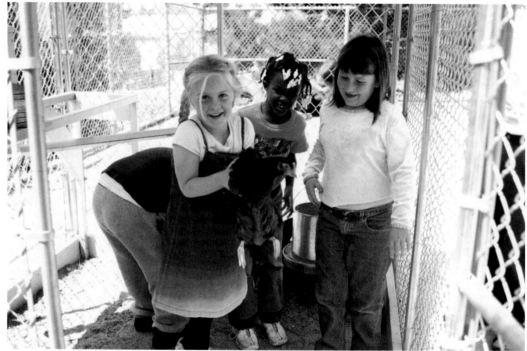

The children contribute to the construction of the chicken house and become its custodians, responsible for the animals, in a formative experience that helps them to recognize, with greater clarity, the importance of living beings in an ecosystem and in the environment on a larger scale. The installation consists in a small ecosystem centering on the chickens. It was made simultaneously in two elementary schools, in Oakland and Tokyo.
The work of construction and maintenance of the chicken coop, and of a small patch of cultivated land, provides an introduction to the ecological cycle that forms the basis for our global environment: organic surplus (in the project we use the leftovers from the school dining hall) is used to nourish the animals; the manure, broken down by micro-organisms, returns to the inorganic and is used as fertilizer for the plants, which by means of photosynthesis convert inorganic molecules into organic ones.

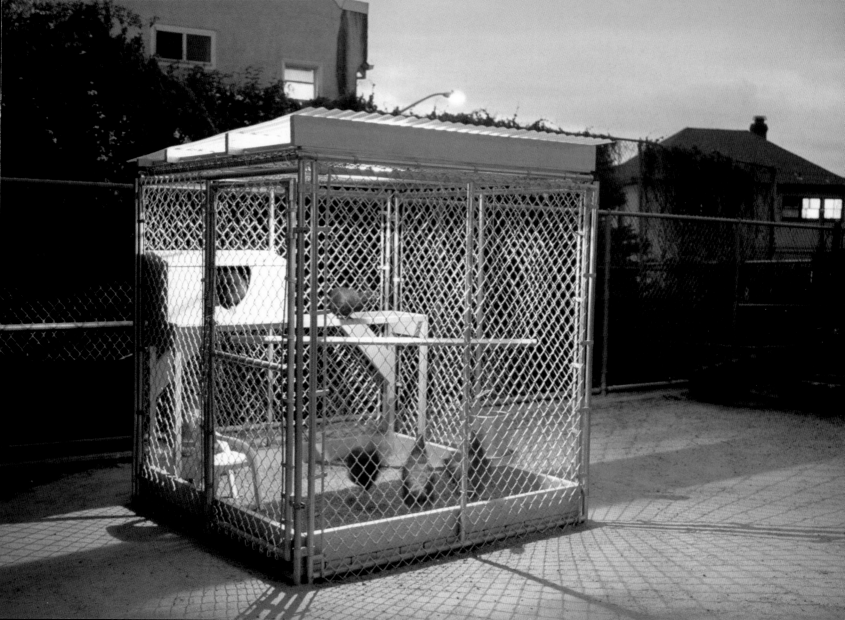

NILS-UDO

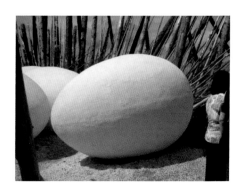

Sketching with flowers. Painting with clouds. Writing
with water. Tracing the May wind, the path of a falling
leaf. Working for a thunderstorm. Awaiting a glacier.
Bending the wind. Directing water and light.
The May-green call of the cuckoo and the invisible trace
of its flight. Space…

–N.-U.

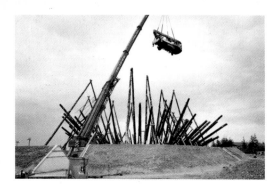

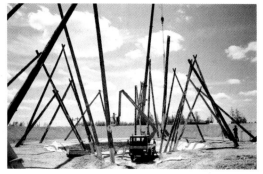

The Nest, German National Garden Festival, Munich, 2005.

Gate House, View of the entrance into the park, Project proposal for
EXPO, Hannover, 2000.

"1972: The sensations are omnipresent. Being a realist I just need to pick them up and release them from their anonymity. Utopias are under every rock, on every leaf, behind every tree, in the clouds and in the wind. The sun's course on the days of equinox; the tiny habitat of a beetle on a lime leaf; the pointed maple's red fire; the scent of herbs in a wooded gorge; a frog's croak in the water lentils; the primrose's perfume on the banks of a mountain creek; animal traces in the snow; the remaining trajectory of a bird darting through the woods; a gust of wind in a tree; the dancing of light on leaves; the endlessly complex relationship of branch to branch, twig to twig, leaf to leaf..."

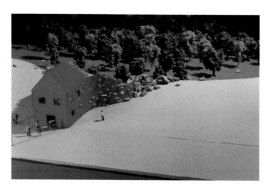

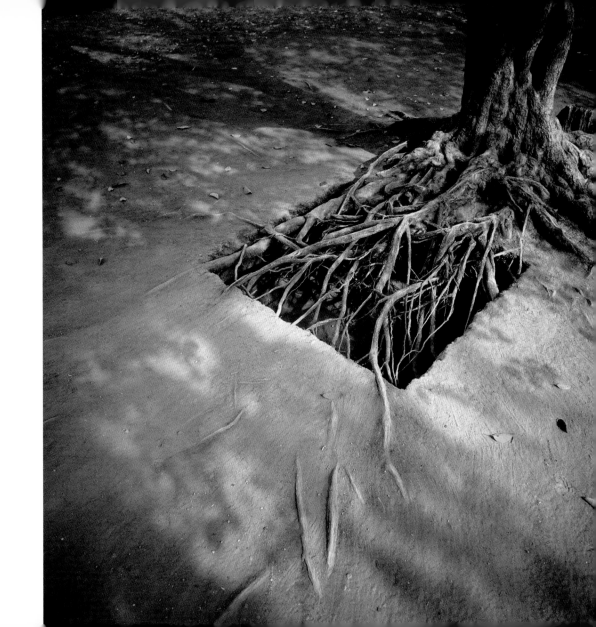

Root Sculpture Parque Chapultepec, Mexico City, 1995.

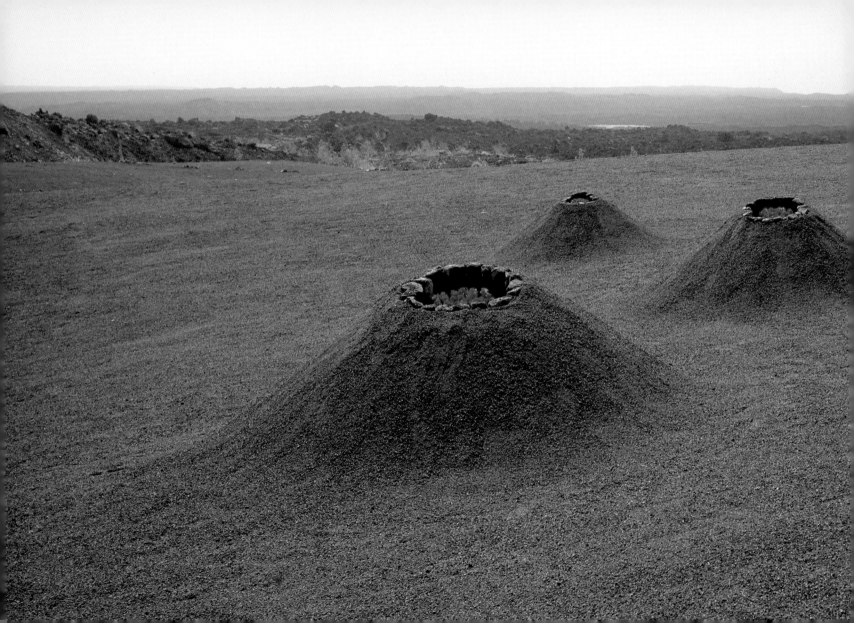

Three Volcanos I Fundación Cesar Manrique, Art and Nature Project. Lanzarote, Canary Islands, 2002. Ilfochrome on aluminium, 70 x 36 inches.
Ash-Palace Fundación Cesar Manrique, Art and Nature Project. Lanzarote, Canary Islands, 2002. Ilfochrome on aluminium, 57 x 40 inches.

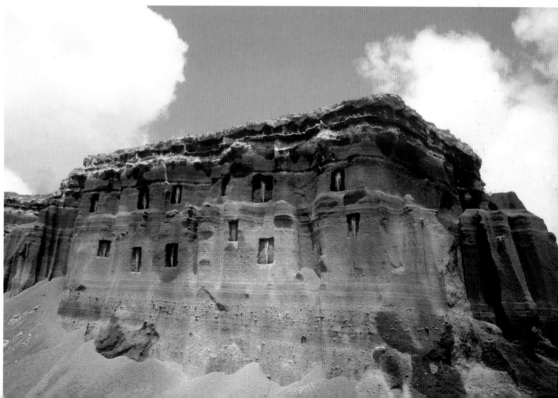

"Implementing what is potentially possible, what latently exists in nature, to literally allow what never existed but was always there to become reality; the ever-present—Utopia. Even one second of a lifetime is enough. The event has happened. I have awakened it and made it visible."

"A steep grassy slope leads down to a hollow flanked by trees and located on the edge of a forest. Profound clay soil. The project reacts and works with the natural conditions encountered there. We dug and modeled the hollow for the nest deep into the bright red ground. Afterwards, we built the high nest walls joggling and wedging long pine trunks with one another. We lined the interior of the nest with green bamboo sticks narrowing more and more towards the inside. The nest ground stayed uncovered. Clay as a metaphor for birth and life."

Clemson Clay Nest South Carolina Botanical Garden, Clemson, U.S.A., 2005.

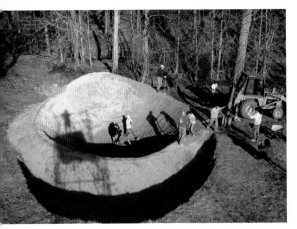

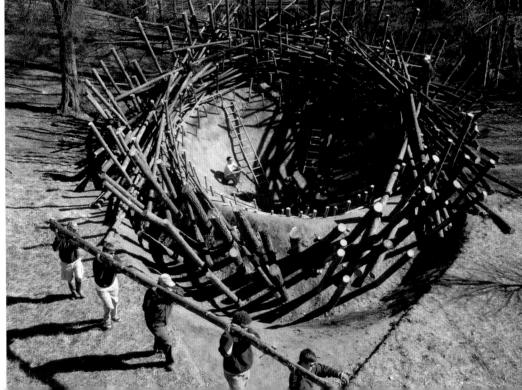

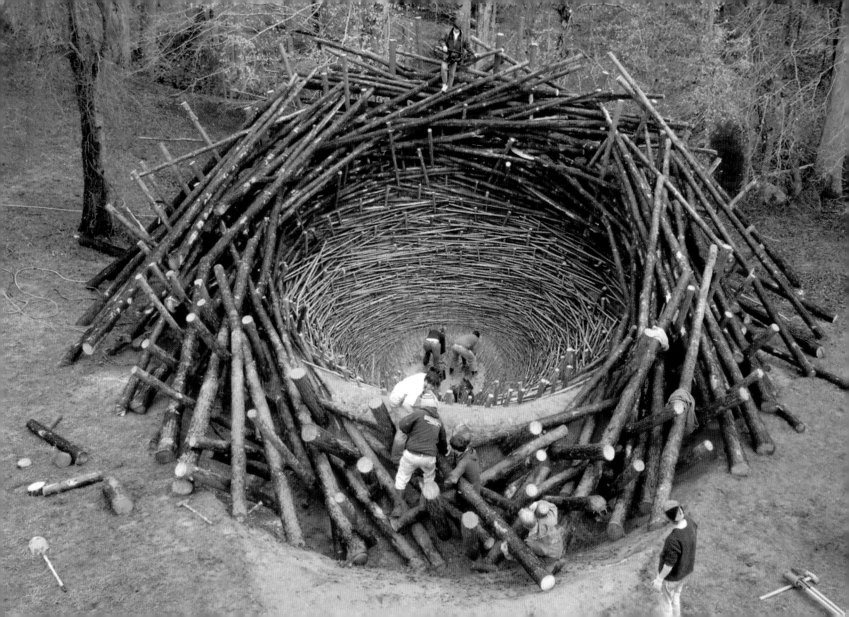

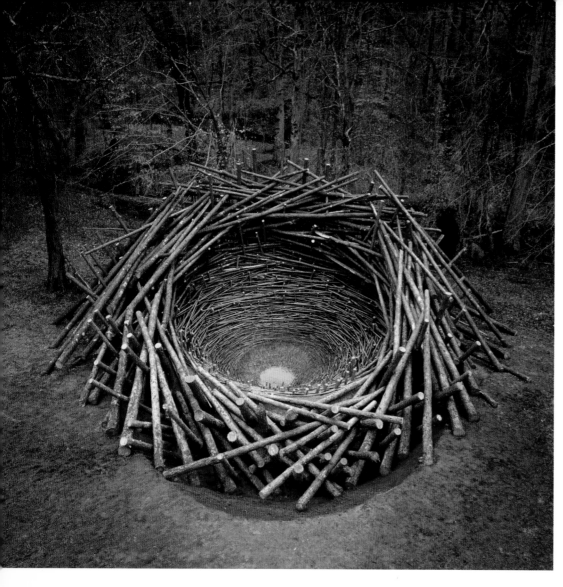

Clemson Clay Nest South Carolina Botanical Garden, Clemson, U.S.A.
Ilfochrome on aluminium, 44 x 49 inches.
Stone-Time-Man Forest Sculpture Trail, Wittgenstein-Sauerland,
Bad Berleburg, Germany, 2001.

"This project is about vulnerability and the temporality of human existence. I discovered this large 150 ton rock in a quarry, where ages ago it had broken out of the face, waiting to be blasted apart. In the face of thoughts and sensations that arise inevitably at the sight of such a monumental block of rock, I wanted to take myself back as far as possible. The rock remained unworked. In the sparse beech tree forest, I created a space that both protects and displays it. There it sits, on top of and surrounded by mighty pillars of tree trunk wood whose dimensions react to the monumentality of this mass of stone. I didn't cut one tree down. I chose every one of those mighty fir tree trunks after they had been knocked over by a storm in the Black Forest."

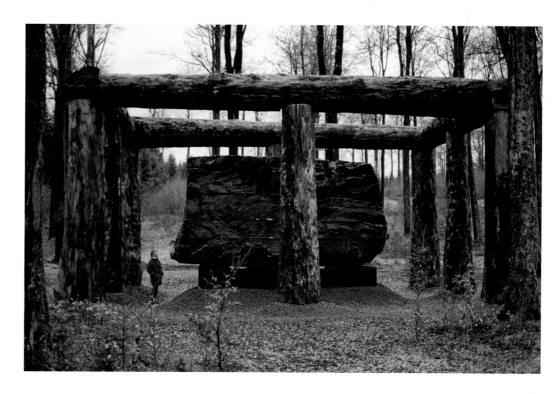

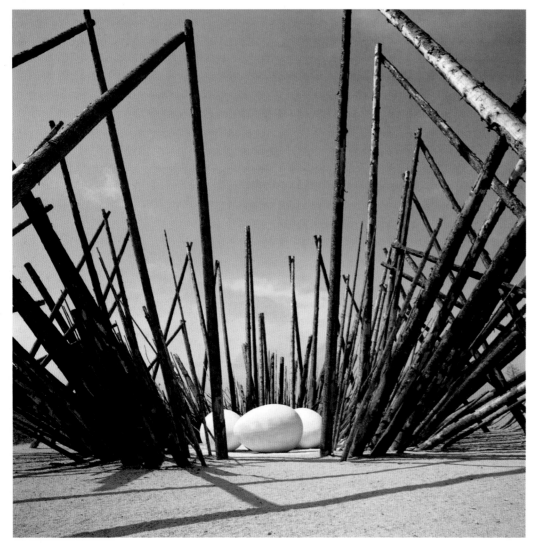

Pinewood trunks reach 59 feet in height. Visitors walk down a platform situated in front of the nest and they find themselves in a place paved with gravel as white as snow where there are five huge white eggs made of stone.

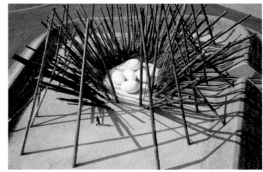

The Nest German National Garden Festival, Munich, Germany, 2005. Ilfochrome on aluminium, 40 x 40 inches.

Morioka Spider Iwate Museum of Art, Morioka, Japan, 2002. Bamboo bars, branches, earth, grass planting. Illfochrome on alluminium, 100 x 49 inches.

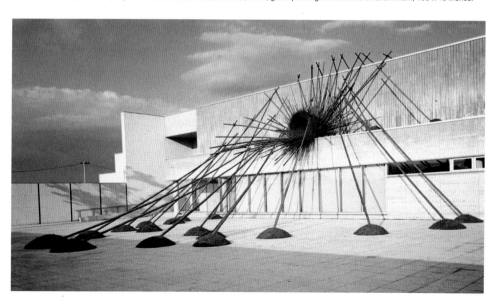

Wasserdorf Project for a watervillage in Lausitzer Seenland, Boxberg, Oberlausitz, Germany, 2003.

"Even if I work parallel to nature and only intervene with the greatest possible care, a basic internal contradiction remains. It is a contradiction that underlies all of my work, which itself can't escape the inherent fatality of our existence. It harms what it touches: the virginity of nature..."

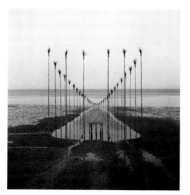 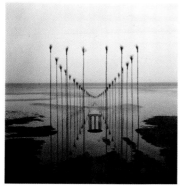 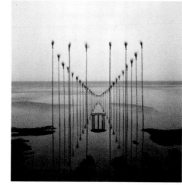

Waterhouse Wattenmeer, Cuxhaven, Germany, 1982. Spruce Trunks, Birch Branches, Willow Switches, Lawn planting 8 b&w photos, Ilfochrome on Aluminium, 49 x 52 inches each.

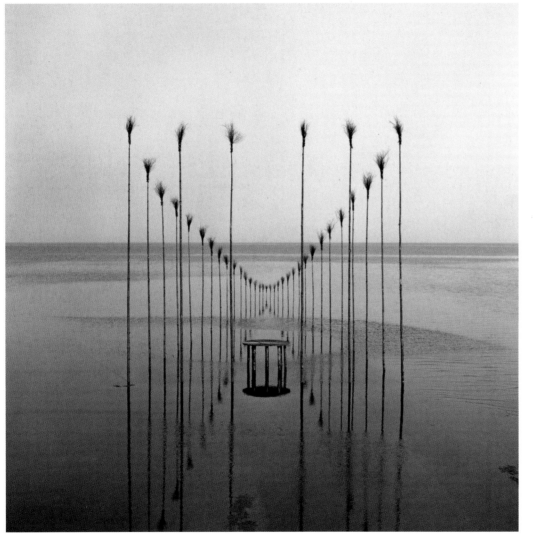
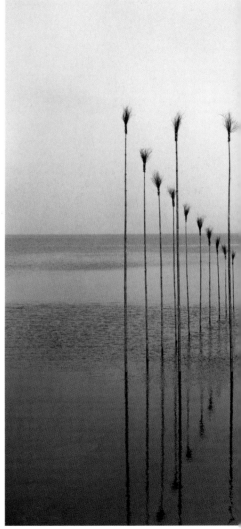

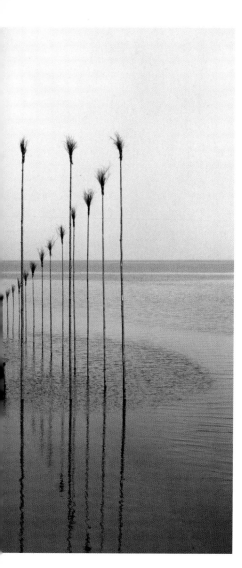
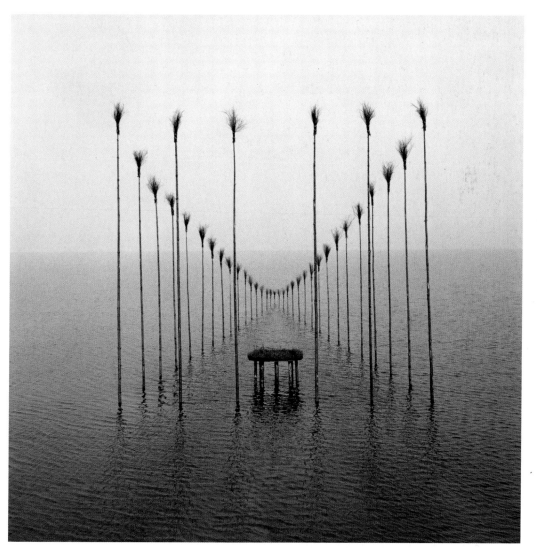

FRANÇOIS

MÉCHAIN

He works outdoors, on a large scale, but also with his bare hands and in relation to the limitations imposed by the size and strength of his body, avoiding any mechanical devices. He develops his projects based on three parameters: study of the memory of the site, the photographic vantage point, the interpretation in the laboratory. He calls his photographs "laboratory sculptures."

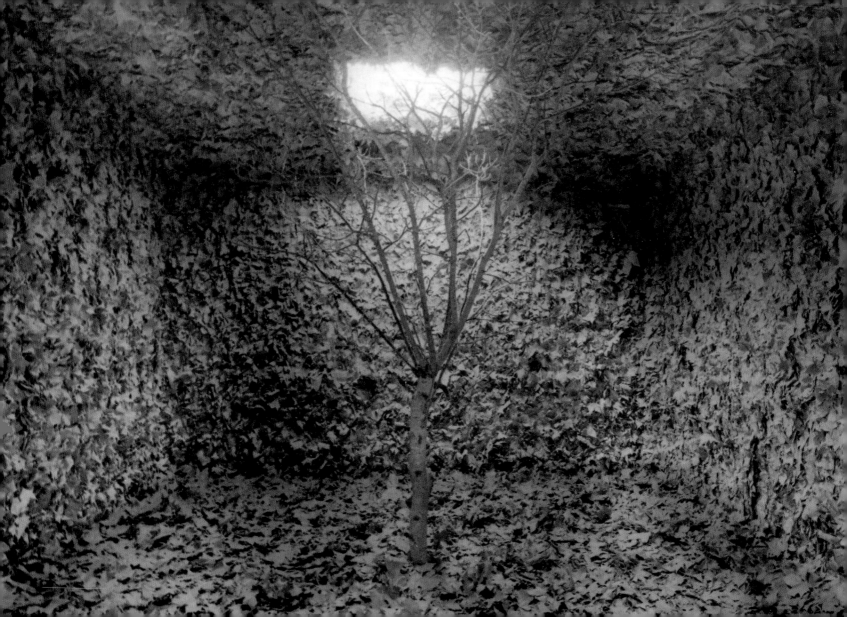

Listening chamber
Dignes-les-Bains, France,
2004. 1/5 Black & white
photograph on silver paper,
46 x 46 inches, aluminium
base. In situ, ephemeral
sculpture: birch, plane
tree leaves, strong smells,
23 x 16 x 9 inches.
Courtesy Galerie Michèle
Chomette, Paris.
Brioude France, 1999.
1/5 Black & white
photograph on silver paper,
37 x 77 inches, PVC base.
In situ, ephemeral sculpture:
oaks and prairie grass,
34.5 x 23 x 11.5 feet.
Courtesy Galerie Michèle
Chomette, Paris.

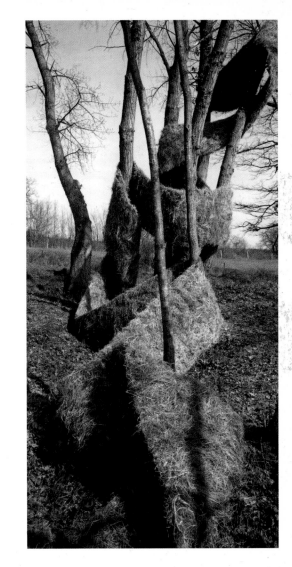

"Three huts with an elementary structure made of grass, branches, and logs found in the park. Gathered together, blocked by the absence of doors and windows, impenetrable, they stand beneath large trees, light and fragile, like abandoned toys."

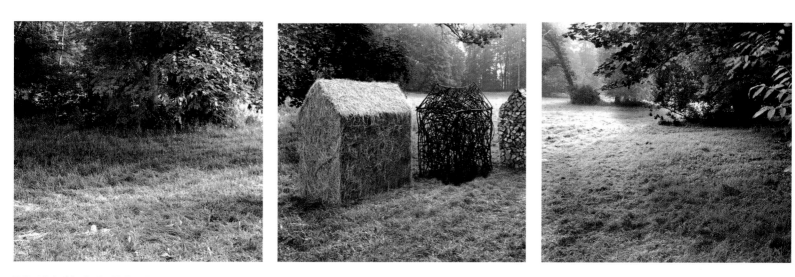

Bailleul Park of the Castle of Bailleul, France, 1994/2005. Triptych 1/5 3 photographs on silver paper, 23 x 20 inches. In situ, ephemeral sculpture: gramineae, dry chestnut boughs, beech logs. 27.5 x 10 x 7.5 feet. Courtesy Galerie Michèle Chomette, Paris.

"assemblage as total memory of the site…"

ARCHITECT WITHOUT ARCHITECT

URE

'S

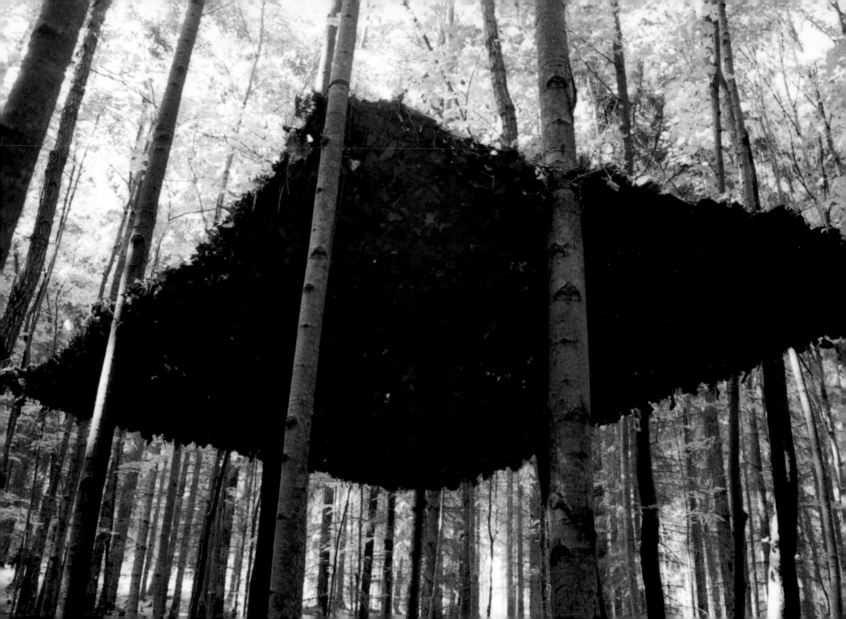

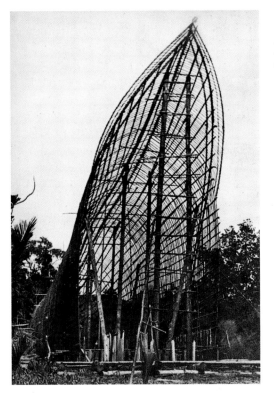

The soaring framework for a men's clubhouse at Maipua, in the Gulf of New Guinea, is made of bamboo poles and will be covered with thatch.

In "Vers une architecture," a milestone text for modern European architecture, Le Corbusier lays the groundwork for a radical renewal, starting with his tendentious observation of American grain silos, Transatlantic ocean liners, and other constructions "without architects." The photographs, precisely retouched, showed pure volumes and imposing structures representing the triumph of geometry, of the new technologies—reinforced concrete and iron—and of total functionalism: the new modernist lexicon, destined to replace historicist decoration and the "facade," a figurative composition applied like a mask of beauty, utterly extraneous to the structure of the building. In 1964 the Viennese critic Bernard Rudofsky organized, at MoMA in New York, an exhibition (and catalogue) that had a vast impact, entitled Architecture without Architects, gathering a wide range of cases of vernacular constructions from all over the world. Comparing a series of very different and often amazing constructions, from Dogon settlements to the "trulli" of Alberobello, Mt. Athos to villages in Guinea and the Congo, Rudofsky's voyage across the continents had the disruptive effect of debunking the clichés and conventions that cling to academic knowledge, putting the focus back on the basic functions of architecture: to build dwellings, villages, shelters, but also ceremonial and monumental structures capable of interpreting and communicating the authentic values of the community.

Ian Krticha, *Baldachin*, Bohemia, 2001. Cords and leaves, 7 x 11.5 feet.

Two working stages and the final result of a construction method used in southern Iraq. The building material is giant reed (fragmites communis) bound into fasces, stuck into the round and bent into parabolic arches. Mats woven from split reed serve for roofing.

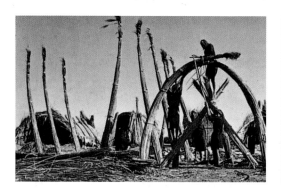 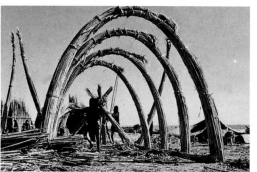 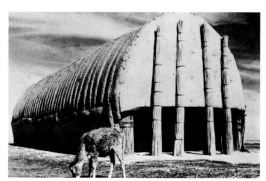

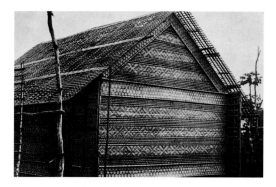

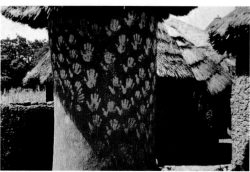

Enclosures made from woven matting are considered fit for a king.
A house in the royal quarter of Bakuba, Congo.
A miniature silo from Yenegandougou, on the upper reaches of the Volta
River (Ivory Coast), about 400 miles from the sea.

The book by Le Corbusier and the catalogue by Rudofsky represent two brilliant lessons, the tip of an iceberg that moves silently through the seas of architecture, and once in a while sinks a vessel that seemed unsinkable. This iceberg is the composite universe of reality, the world where people live, imagined and implemented by its inhabitants, whether they are Zimbabwean hunters or Milanese fashion designers. Architecture, at times, wraps itself in abstruse canons, separating itself from the rest of the world, seeking refuge in an abstract stratosphere where its own laws hold sway over those of good common sense and fantasy. The aim of this book is to contribute to reflection on our ways of building and inhabiting the world, through the example of a series of works created for the most part by artists who have come to terms with the process of construction. These works contain, first of all, a question regarding our relationship with places and materials. They also contain answers that indicate a particular focus, a warning, a special pleasure in approaching and dealing with natural forces. The energy of wood, of willow or maple branches, of chestnut logs and grasses, of stones lifted by hand or trees planted and grown one by one, survives the constructive process and fills these inhabitable objects with a perception of the mysterious depth of nature. Each work is a unique, unrepeatable artifact, precisely because it has been made with artisan technologies. At the same time, it is capable of addressing more general issues of love for nature, but also the sensation of danger that can stimulate us, the force

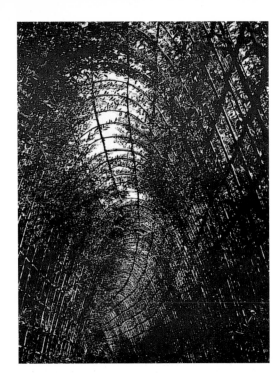

A Japanese arbor composed of bamboo poles and climbers.

of wood but also its fragility, the weight of stone but also its readiness to be transformed into something residual, a ruin, returning to its natural state. These reversible and sustainable constructions use economical materials, easy to find and transport, worked with minimum technical means and often with very limited architectural notions. Many of the works are made by the artists with their own hands, almost without the use of other tools. In many cases they have been assisted by groups of volunteers, who participate for pleasure and passion, happy to be involved in a very special human and artistic experience. In these works, therefore, we find the pleasure of work done together, the taste for building something unique and memorable, a "monument" on a human scale that will remain as a memory of that experience and as a value, a collective legacy to be shared and protected. Of course there are complex paths of ideation behind these works, the background of an artist or the expertise of an architect, and then there is the development of the project, which, wherever possible, we have documented with drawings, sketches, and models to shed light on the scope of reasoning and the synthesis of the basic idea. Looking through the works we have gathered a lively landscape emerges, populated by environmental art installations and temporary constructions, interventions of naturalistic engineering and architecture, works of Land Art, ecological sculptures, volunteer activities, educational experiences. Observing the overall picture, in spite of evident differences we can identify a field of attraction that leads toward a specific intertwining of art and nature, and toward a new awareness of architecture and the landscape. This book has been developed and produced outside the established critical grids, pursuing the idea of stimulating an encounter of living forces, that come from different areas of expertise, with different objectives, but speak a similar language and can collaborate to hypothesize a better, more positive, more responsible world. Ideas, projects, and works that implement an action of revision and updating of architectural culture, permitting us to come to terms, in a new awareness, with two decisive challenges: the modes with which we intend to transform and conserve the environment, and the symbolic representation of the way in which we intend to live on our planet.

The images used to illustrate this text come from: Bernard Rudofsky, *Architecture without Architects: A Short Introduction to Non-Pedigreed Architecture* (Garden City, N.Y.: Doubleday & Company, 1964).

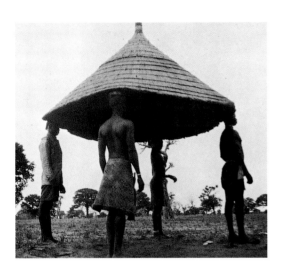

Movable architecture in Guinea and Cherrapunji, India.

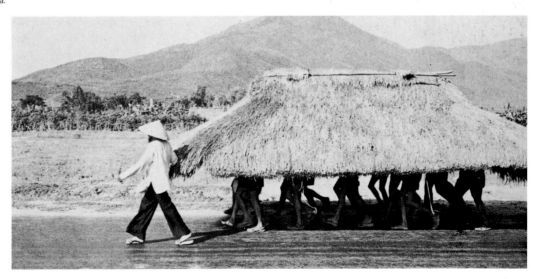

ARMIN SC

IUBERT

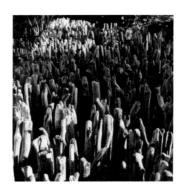

As a producer of natural artifacts my choice goes to materials nature provides generously: stones, pebbles, branches and twigs, scrap timber, earth.... I ambitiously gather and reorganize these utterly unspectacular pieces based on their characteristics, and I give them new forms and new meanings. As elements of natural architecture, these leftovers take on dignity and value.

–A. S.

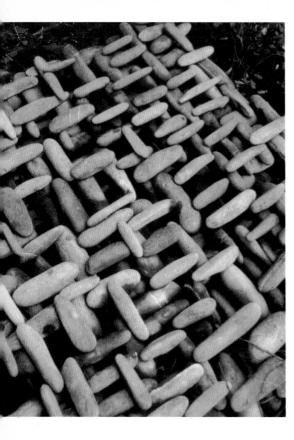

Pebble Objects Selected pebbles, Lustenau, Austria, 2001.
Pebble Structures Selected pebbles from the Rhine, Lustenau, 2002.
Nucleus Acacia sculpture, working model, 2004.

"Walking on the riverbank one realizes that the stones are not all the same. The stones, selected from thousands and thousands of examples, have a similar form and can develop those homogeneous structures that are then made into small sculptures, like the object of pebbles and the sensitive path."

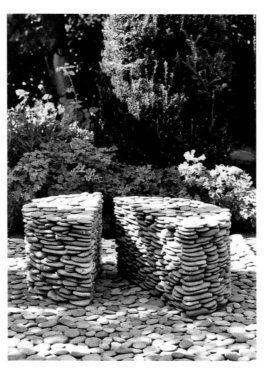

"These small sculptures are made of similar elements, and the coherence comes from the fact that each pebble is positioned in response to its static properties. Some sculptures remain for several years; some are altered by birds, stray cats, and curious hedgehogs."

"When people encounter this form of natural art in their habitat they are surprised and amazed by materials they thought they knew, like logs, roots, stones, stems, leaves. There is an effect of recognition of these materials in a different context."

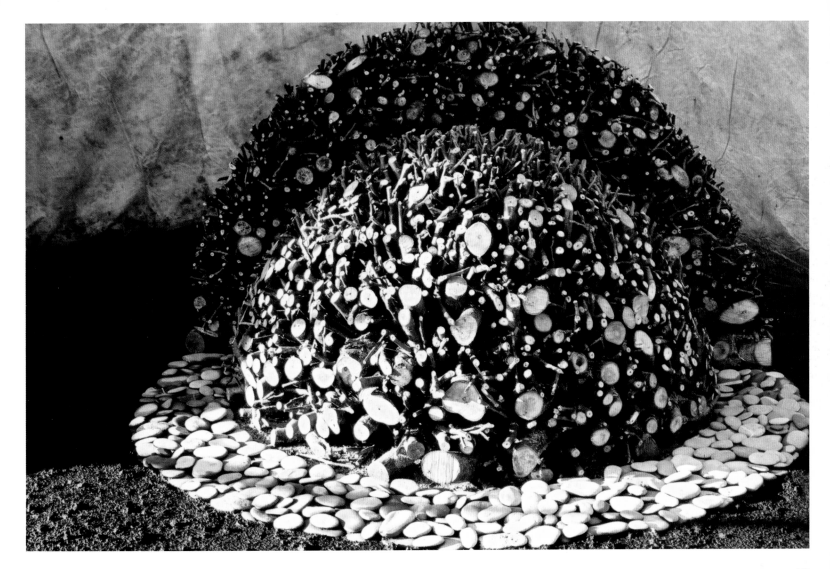

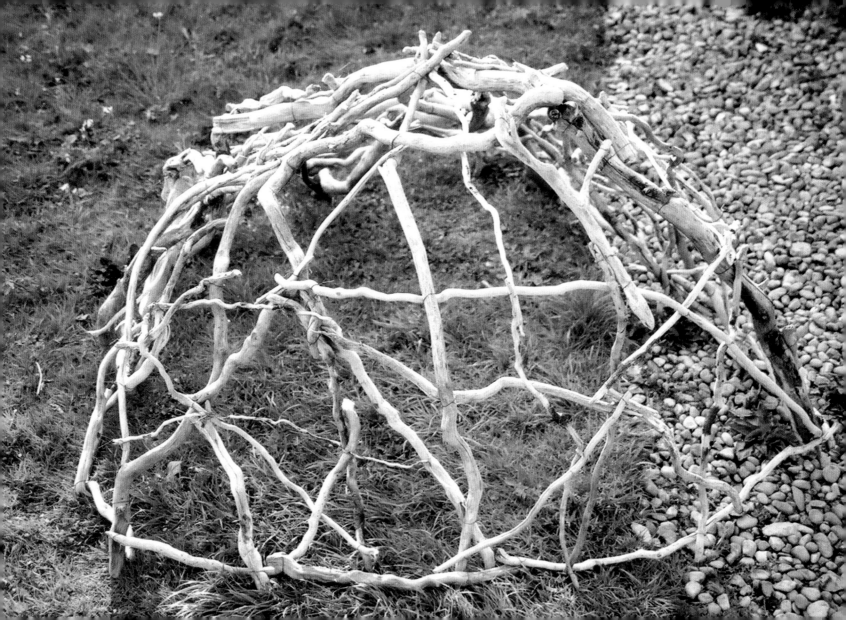

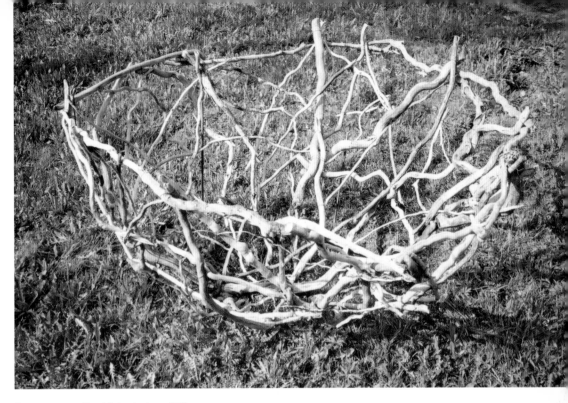

Convex : concave Bound timber, Lustenau, 2003.

"An attempt to give a rigorous form to irregular materials. The convex part is conceived as a protective element, the concave part as a functional accumulator."

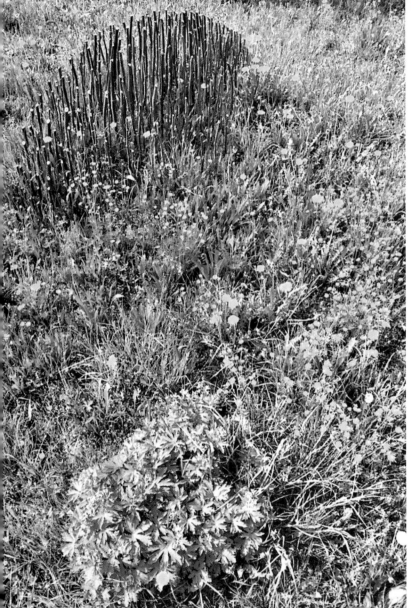

Walnut Lustenau, 2003.

"This object is found in my garden, and is composed of small branches from our walnut tree. It is an interpretation of the half-shell as a spatial experience: physically, the material is defined more by the spaces than by the solids."

"My natural works are based on personal routes, on feelings of conscience, emotion, or affection for the natural environment. From these premises, I try to concentrate on the signs and forms that should allow anyone access to a discourse on our perception and our responsibilities with regard to nature."

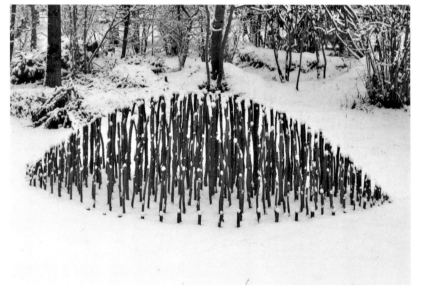

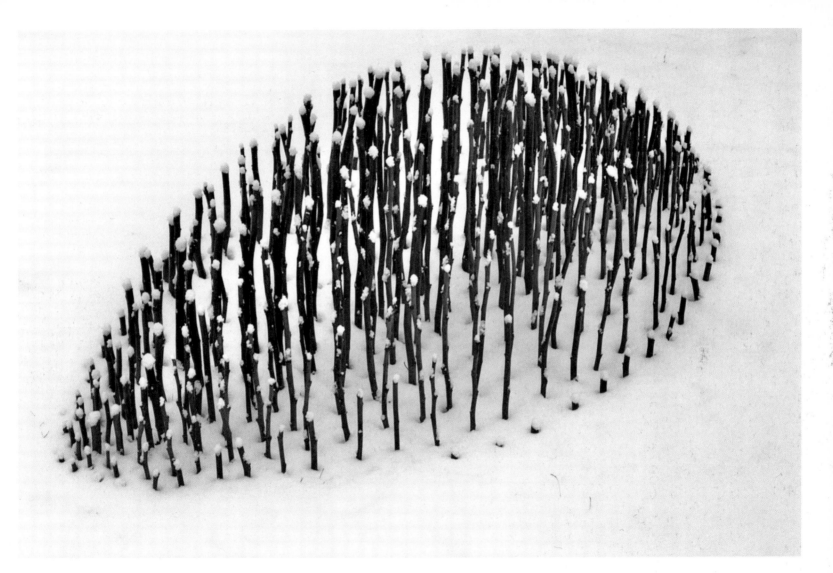

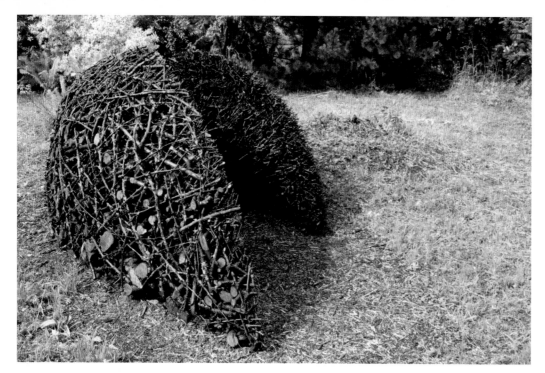

Organism Lustenau, 2005. Assemblage of pear branches and logs, height 4.5 feet, length 15 feet.

"What sort of creature is that in the middle of the meadow? Look, is it moving? It's opening! This figure in two parts is dedicated to all the creatures that dig, crawl, and fly in its vicinity. The internal structure is visible beyond a network of slender branches that cover the body like a skin. A clear cut divides the organism and alludes to a sudden movement."

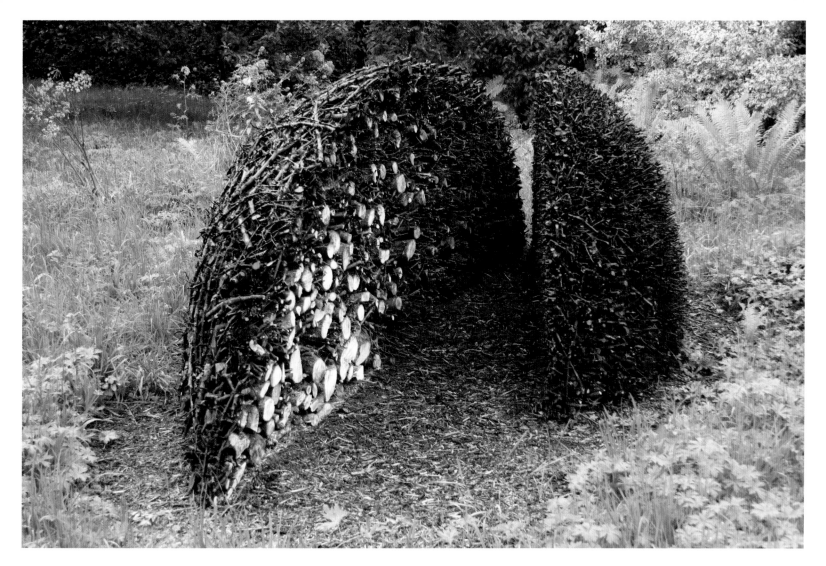

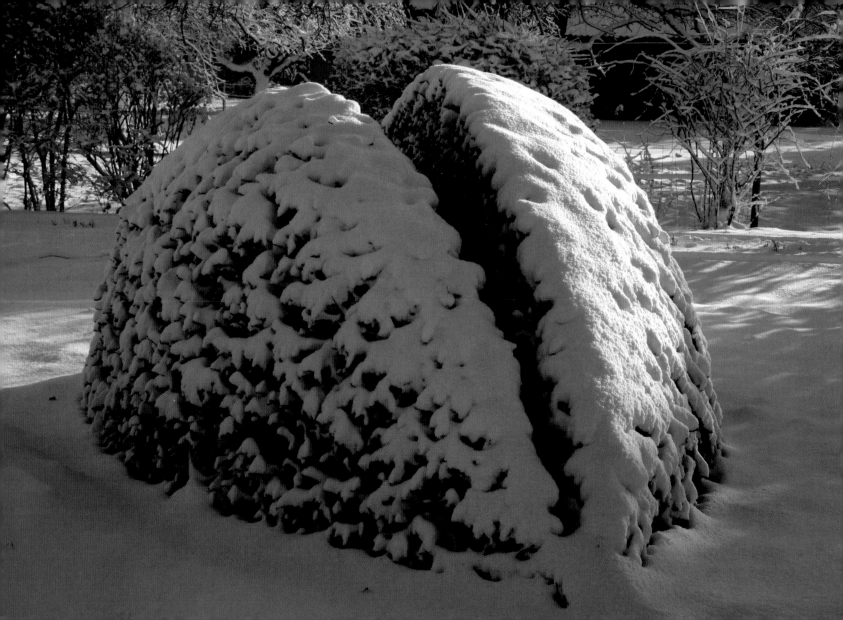

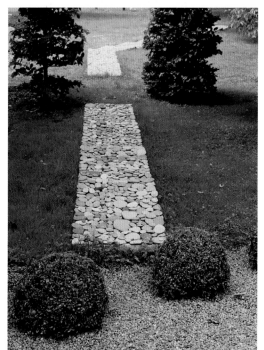

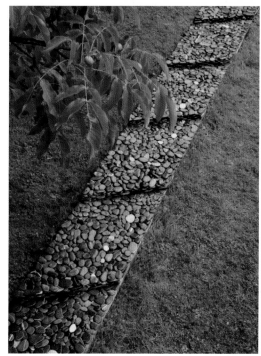

Sensitive path Flat stones, two segments of 13 and 36 feet, Lustenau, 2005.

The temporary installation was a tribute to the cultural event "In the garden," held in two nearby gardens in the summer of 2005. In conceptual terms, the work refered to conversation between neighbors, seen in different manners and meanings. With steps of about one meter, the path of carefully arranged stones develops, step by step, between the houses of two neighbors.

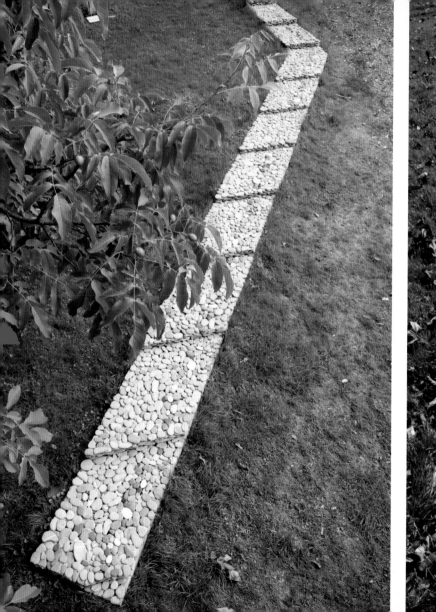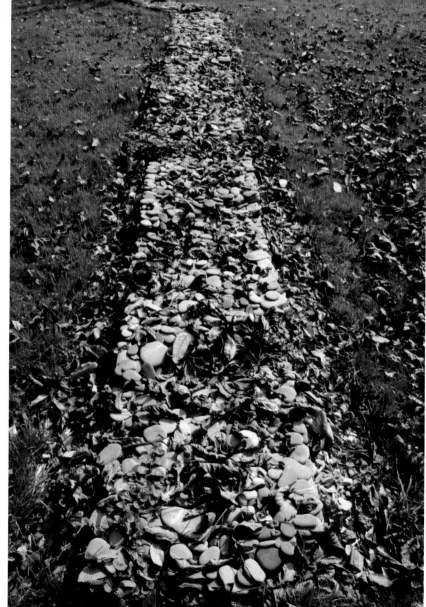

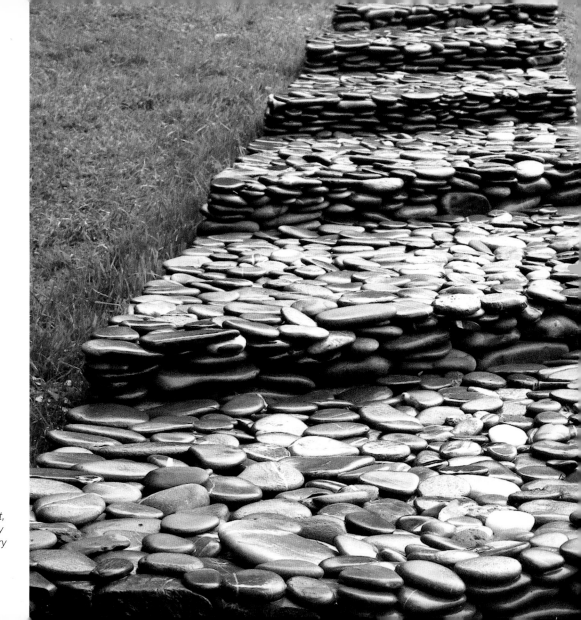

"Artworks should stand out for the clarity of the layout, the structure, the relations with the context. Then they can become those signs that guide us in the discovery of new territories. Therefore I call some of my works landmarks."

CHRIS DRU

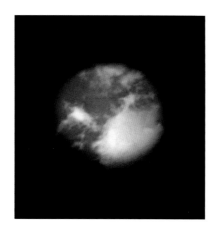

The cloud chambers work on the principle of a camera obscura. The interiors are dark, the entrance being from a door or curved passageway, the floor or viewing surface is white, and there is a small aperture or lens in the ceiling or wall. Images of clouds, branches, waves and landscape, are thus projected inside. These cloud chambers are still, silent, meditative, and mysterious spaces. They are often built underground, so that in these dark spaces what is outside is brought in and reversed. Clouds drift silently across the floor.

–C.D.

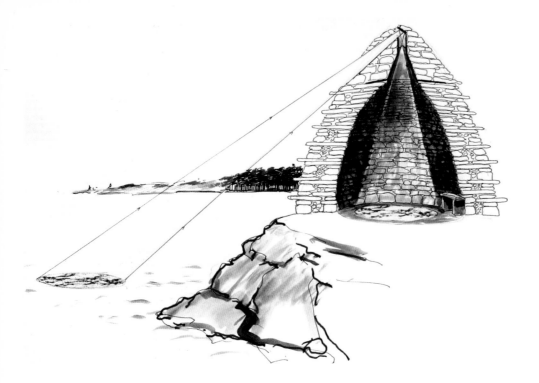

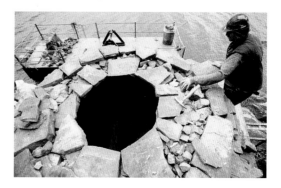

Wave Chamber Kielder Water and Forest Park, Northumberland, England, 1995.

Wave Chamber is a dry masonry construction, 13 feet in height, made with 80 tons of stacked stone. The interior is a camera obscura, with a lens and a mirror positioned at the top and aimed toward the lake. The rippled surface of the water is projected onto the light floor, while the sound of the waves echoes. The work was commissioned by the Northumbrian Water and Forest Enterprise for the event Visual Arts UK 1996.

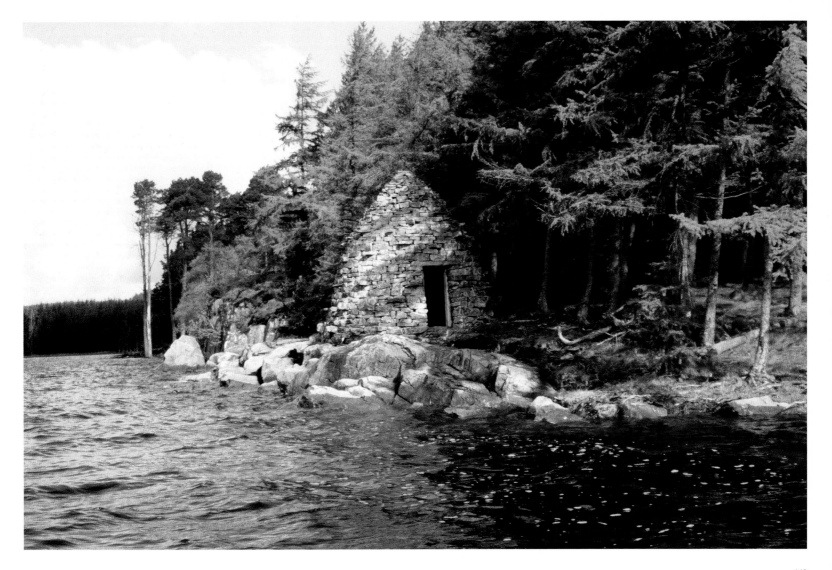

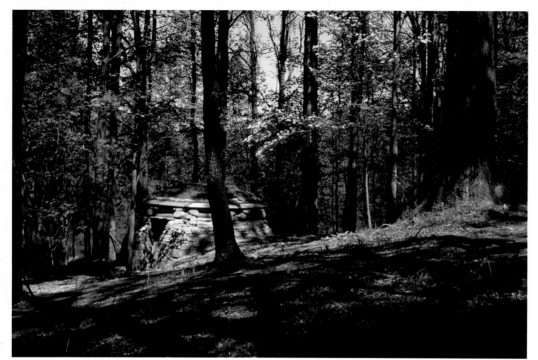

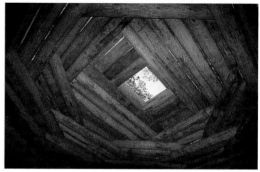

Cloud Chamber For The Trees And Sky
North Carolina Museum Of Art, U.S.A., 2003.

Consisting of large trees, partially buried at the foot of a wooded hillside on the land of the North Carolina Museum of Art, the work is the first in a series for an outdoor sculpture trail. The room has an internal diameter of 14 feet, and is built with stone masonry. The roof is formed by an octagonal vault of logs, covered with grass on the outside. Inside, the walls and floor are treated with white cement. Through an opening in the roof, the image of the nearby trees is projected inside the room. The trees seem like roots, suspended inside the dark underground space.

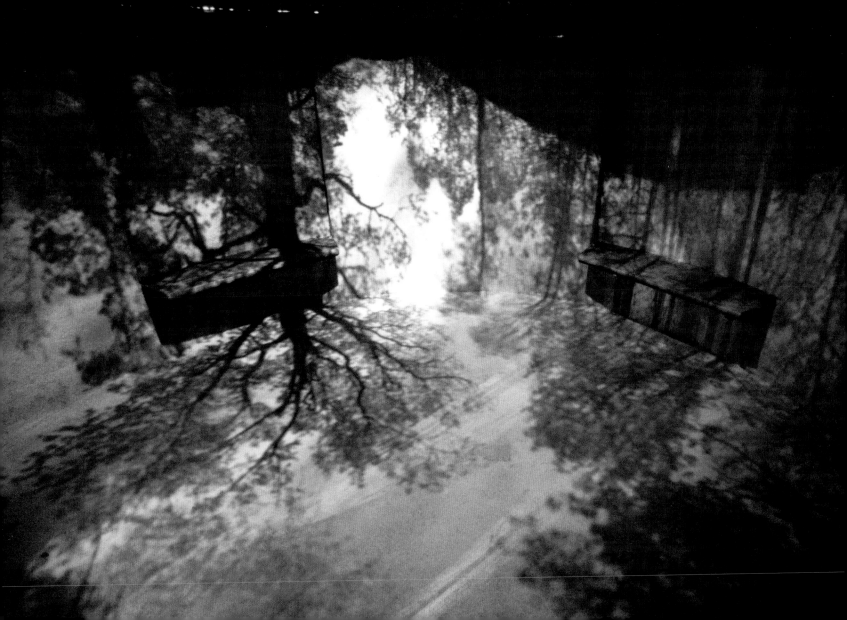

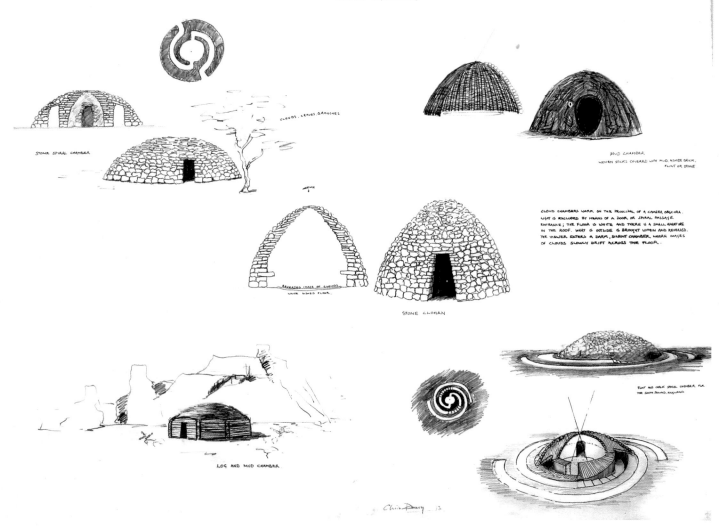

STONE SPIRAL CHAMBER

CLOUDS, LEAVES, BRANCHES

MUD CHAMBER
WOVEN STICKS COVERED WITH MUD, ADOBE BRICK,
FLINT OR STONE

REVERSING IMAGE OF CLOUDS
WHITE DOMED FLOOR.

STONE CLOHAN

CLOUD CHAMBERS WORK ON THE PRINCIPAL OF A CAMERA OBSCURA.
LIGHT IS EXCLUDED BY MEANS OF A DOOR OR SPIRAL PASSAGE
ENTRANCE; THE FLOOR IS WHITE AND THERE IS A SMALL APERTURE
IN THE ROOF. WHAT IS OUTSIDE IS BROUGHT WITHIN AND REVERSED.
THE VIEWER ENTERS A DARK, SILENT CHAMBER, WHERE IMAGES
OF CLOUDS SLOWLY DRIFT ACROSS THE FLOOR.

LOG AND MUD CHAMBER.

FLINT AND CHALK SPIRAL CHAMBER, FOR
THE SOUTH DOWNS, ENGLAND.

Eden Cloud Chamber Eden Project, Cornwall, England, 2002.

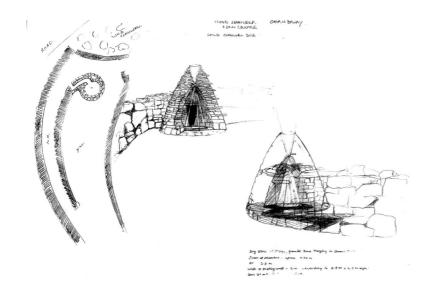

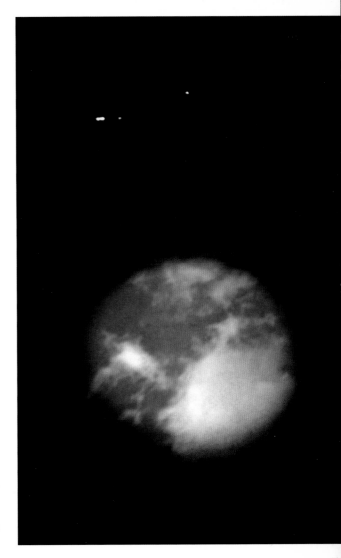

Constructed with 120 tons of Cornish slate, the room is located at the end of a granite wall, which together with another, parallel wall, forms a narrow curved passage based on a diameter of 20 feet. Accessed from both ends, the tunnel penetrates the tiny cell, a space 8 feet in diameter with seating for two people. Through the lens at the top of the roof the view of the clouds in motion is projected onto a screen placed in the floor. Overall height: 16 feet.

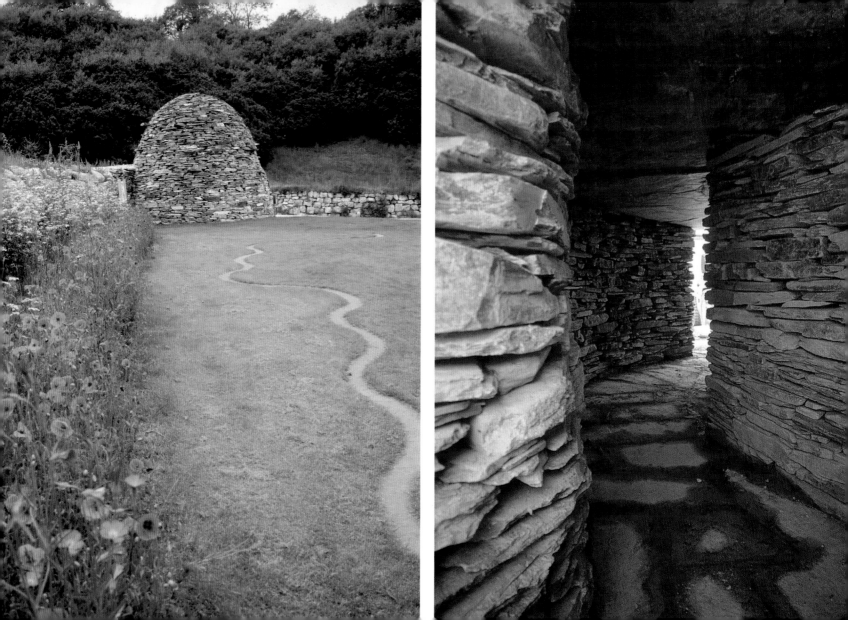

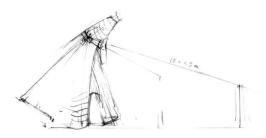

Reed Chamber Wildfowl and Wetland Centre, Arundel, Sussex, England, 2002.

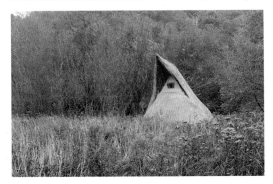

The room, with a thatched roof, is built on a platform suspended amidst rushes. A lens and a mirror project, inside the room, the image of the tops of the rushes waving in the wind. The structure is composed of willow strips stiffened by curved chestnut poles. The diameter, at the ground, is 16 feet by an overall height of 20 feet. Thatched roof made by Chris Tomkins.

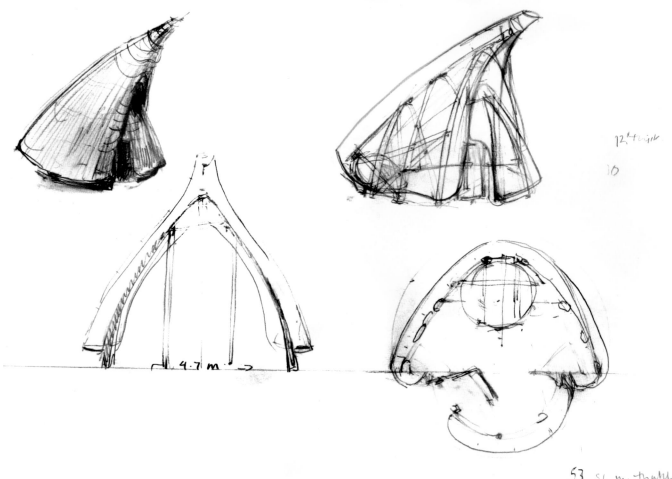

4.7 m

12" thick

10

53 sq m. thatch.
at 100 sq m = 5300

156

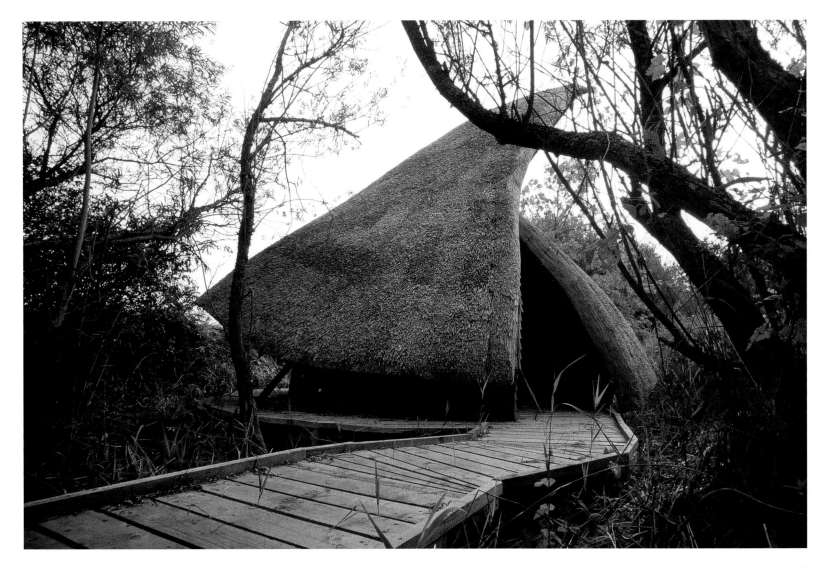

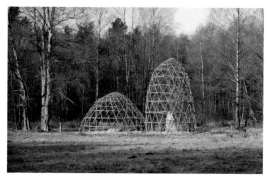

Willow Dome On The Este Neddernhof, (Hamburg), Germany, 2000.

Two cupolas made with planted, woven, and grafted willow branches that grow to form a single tree with a projection in the form of an 8. At the center of each cupola there is a stone; one is standing, the other lying down. The taller cupola will have the seedlings pruned so that it will grow starting at 13 feet in height. The smaller cupola will have the seedlings trained inward, so as to form a darker, more chaotic space, a place where it will be possible to sit down and listen to the sound of the stream flowing nearby. At a certain moment the work will be abandoned and allowed to grow spontaneously. Update. In September 2004 I returned to the scene: I found that the pruned cupola was growing vigorously, and I weaved some seedlings onto the structure. It is proceeding very well.

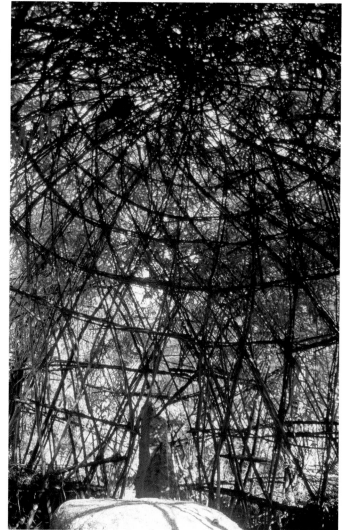

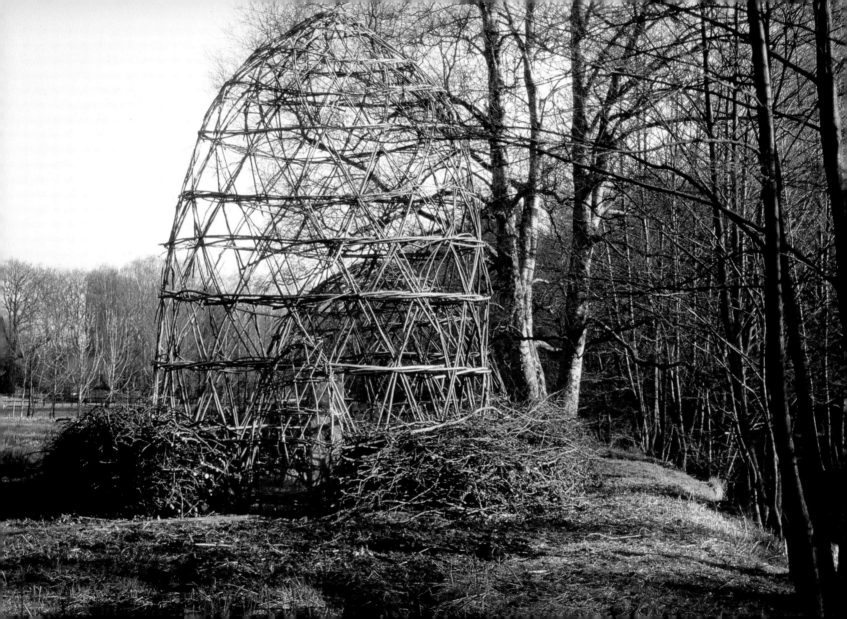

PATRICK D

OUGHERTY

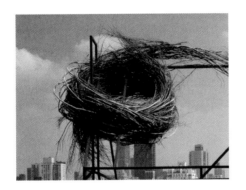

"My affinity for trees as a material seems to come from a childhood spent wandering the forest around Southern Pines, North Carolina—a place with thick underbrush and many intersecting lines evident in the bare winter branches of trees. When I turned to sculpture as an adult, I was drawn to sticks as a plentiful and renewable resource. I realized that saplings have an inherent method of joining—that is, sticks entangle easily. This snagging property is the key to working material into a variety of large forms."

–P. D.

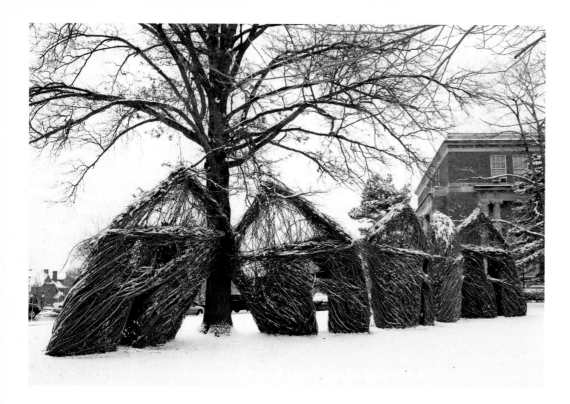

Homebound Maple saplings. 20 x 16 x 20 feet. Socrates Sculpture Park, Long Island, New York, 1990. Photos by Dennis Cowley.
Threadbare Maple and willow saplings. 20 feet high. The University of Cincinnati, Cincinnati, Ohio, 2002. Photos by Jay Yocis.

Patrick Dougherty is known for large-scale installations that incorporate tree saplings. He often uses saplings gathered near the installation site, adjusting his designs to the different ways local materials bend and respond in his hands.

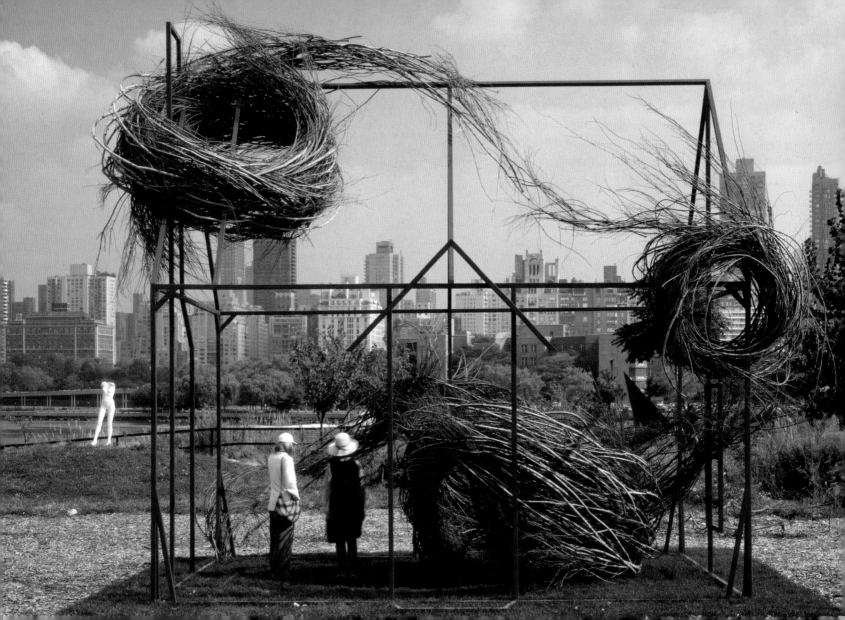

At first Dougherty worked with clay. When he realized he wanted to make larger pieces, he decided to experiment with branches, attempting to "impose some of the ideas I had associated with clay—fluidity, immediacy, and the ease of applying marks to the surface." His work reveals the direct influence of drawing, seen in the transposition of the shading technique and the way the branches are arranged. Often eccentric and outlandish, his sculptures intrigue and amuse viewers, like surprising, mysterious presences.

Running In Circles Willow and maple saplings. 22 feet high. TICKON Sculpture Park, Langeland, Denmark, 1996. Photos by Hatten.

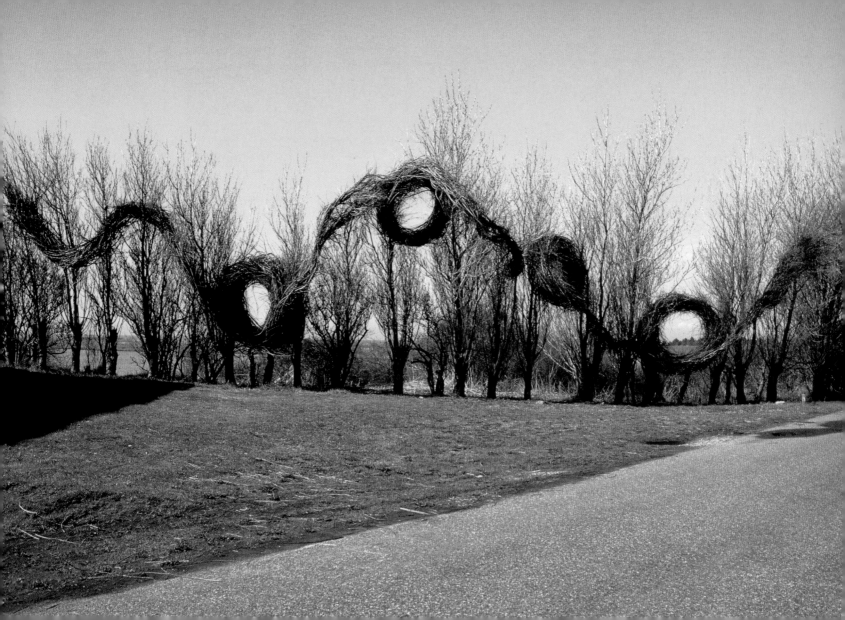

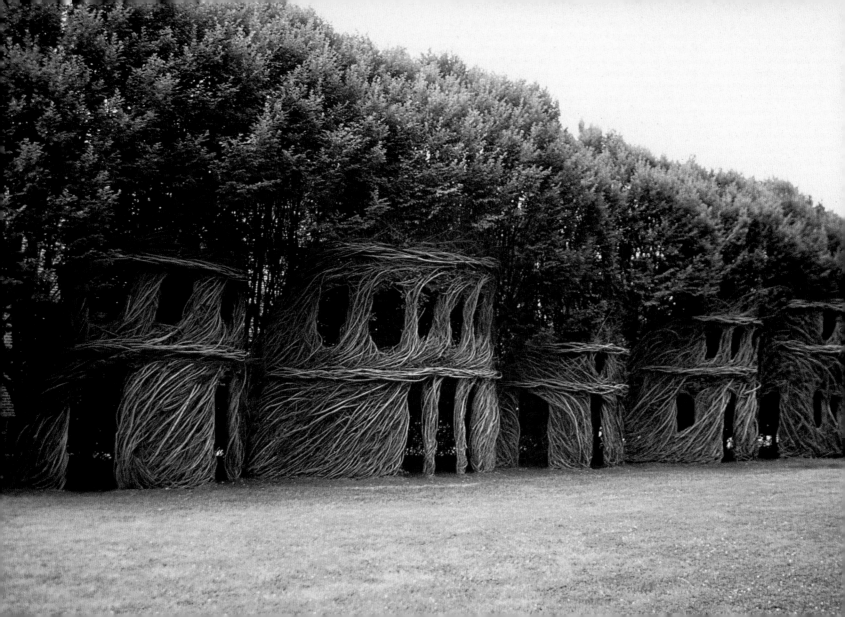

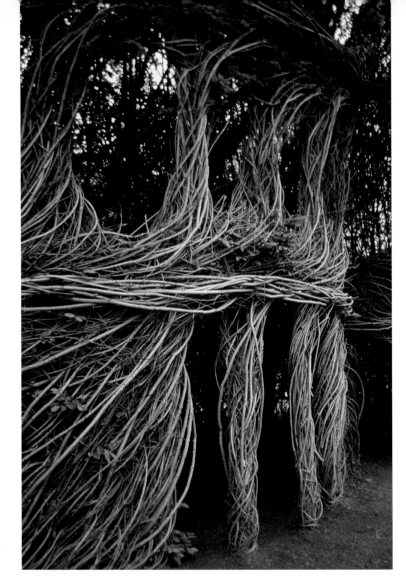

Just Around The Corner Mixed hardwood saplings. 100 feet long x 15 feet wide x 18 feet high. New Harmony Gallery, New Harmony, Indiana, 2003. Photos by Dole Dean.

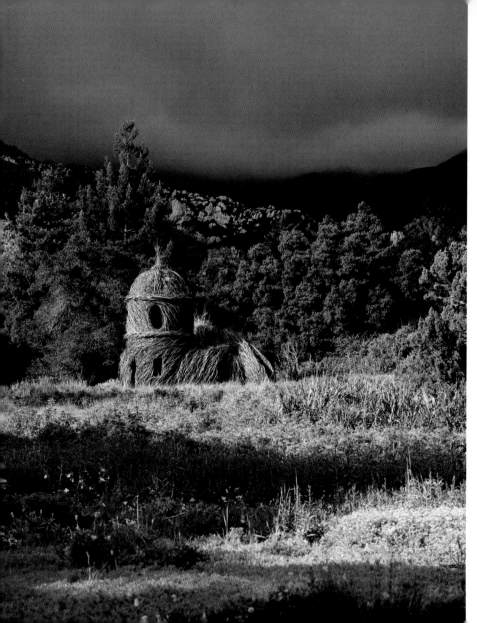

Toad Hall Willow saplings. 30 feet high x 30 feet wide x 30 feet in length. Santa Barbara Botanic Garden, Santa Barbara, California, 2005. Photos by Nell Campbell.

Toad Hall—the name comes from the children's book "The Wind in the Willows" by the Scottish author Kenneth Grahame—has a two-storey tower and a labyrinth of internal rooms and passages. Built in February 2005, the willow house should last for about two years.

Putting Two And Two Together Willow and Maple saplings. 30 feet high. Woodson Art Museum, Wausau, Wisconsin, 2004. Photos by Richard Wunsch.

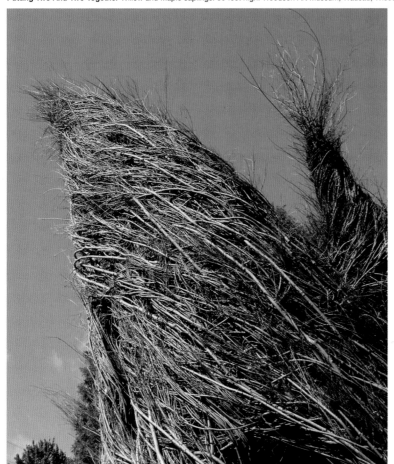

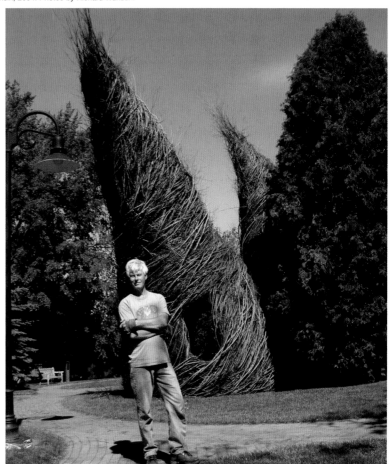

Short diary of the making of *Putting two and two together*.

7 and 8 June 2004. Museum staff and volunteers accompany Dougherty southeast of Wausau to collect branches, especially of maple, that will be used for the support structure. Equipped with two chainsaws, many bottles of water, and insect repellent, the team defies the heat, humidity, mud, and ticks in search of young trees with a height of about 20 feet and a diameter between 1 to 2 inches. At noon they have already gathered at least 150 trees and lined them up on the truck. After unloading them in the Margaret Woodson Fisher Sculpture Garden, the team takes a break for an abundant picnic. Then they head into the Moisinee zone to collect other branches, from 10 to 15 feet long, that will be woven into the structure.

10 June. Work starts early, with Patrick and the team blazing a trail through the thuja trees. The passage, which will be part of the sculpture, allows visitors to pass through the work, emerging on the opposite side. Three or four large maple branches of the support structure are placed in each of the 34 holes, dug to a depth of 2.5 feet. This operation makes it possible to begin to imagine the form of the sculpture. In the meantime, other volunteers trim the maple and willow branches. According to Patrick, the willow branches should be the first to be woven into the structure.

22 June. About twenty volunteers arrive, students who help to remove the leaves from the branches. In the meantime new willow and maple branches arrive for cleaning. Patrick, with the weaving team, continues to reinforce the inside and outside of the cones to the southwest, while visitors arrive to observe the sculpture and the team at work. Many take pictures of the work in progress, saying they will return when it is completed.

25 June. Formed by about 2000 young willow and maple trees solidly woven together thanks to the help of at least eighty volunteers, the monumental installation is now open to the public. It will remain on view until October 2005.

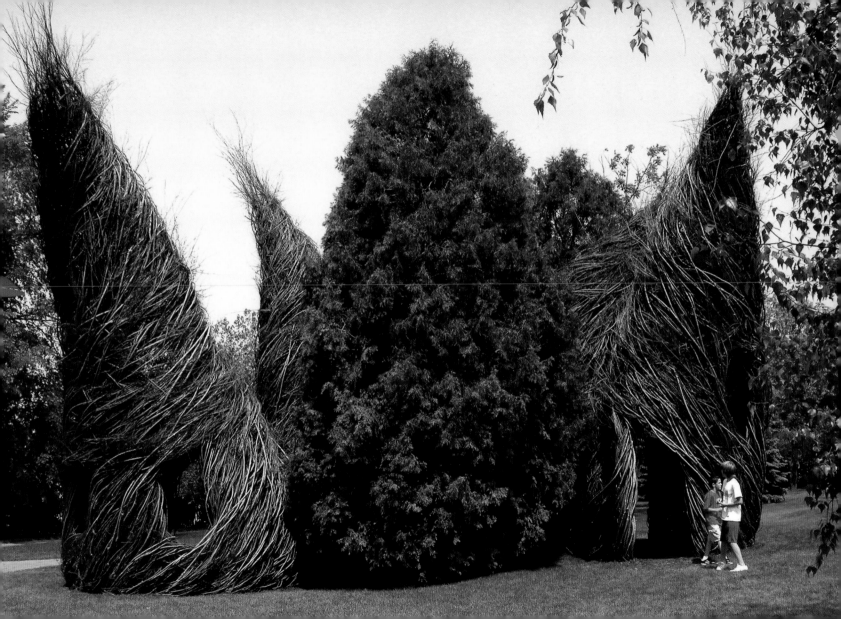

EDWARD N

We received a phone call from a monk who asked us to lend a hand in building another bridge, in Tibet, that would connect a village to a nearby orphanage. We are organizing a visit and we will put together a new team. Watch this space!

–E. N.

Students and volunteers reach the site, trucks arrive with the construction materials and the work begins.

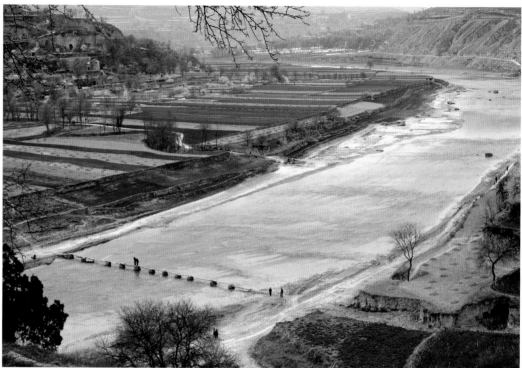

After the fall harvest, the inhabitants of the village of Maosi, in northwestern China, were gearing up for one of their annual tasks, the construction of the bridge. They gathered stones and straw for the points of contact with the ground, and logs for the bridge, and in fifteen days the thing was built. They knew that this bridge, like its predecessor, was destined to be swept away by the high water following the summer rains. For the 300 children who go to school, the crossing of the river is a daily ritual. By now they have become very good at balancing on the narrow, shaky beams, though there are frequent slips, falls, and scrapes. Some of them just decide to walk in the water, but they run the risk of tripping and getting soaked. In the winter it is possible to skate on the ice, but the danger of falling into the icy water is quite high. When a mother and child lost their lives, swept away by the water, Edward Ng, professor of architecture at the Chinese University of Hong Kong, put together a group of volunteers from Hong Kong and Xi'an to build a permanent bridge, a small gift for the children of the village. Financed by Sir David Akers-Jones, the idea took the form of a project developed with the help of Tony Hunt, one of the leading English structural engineering experts.

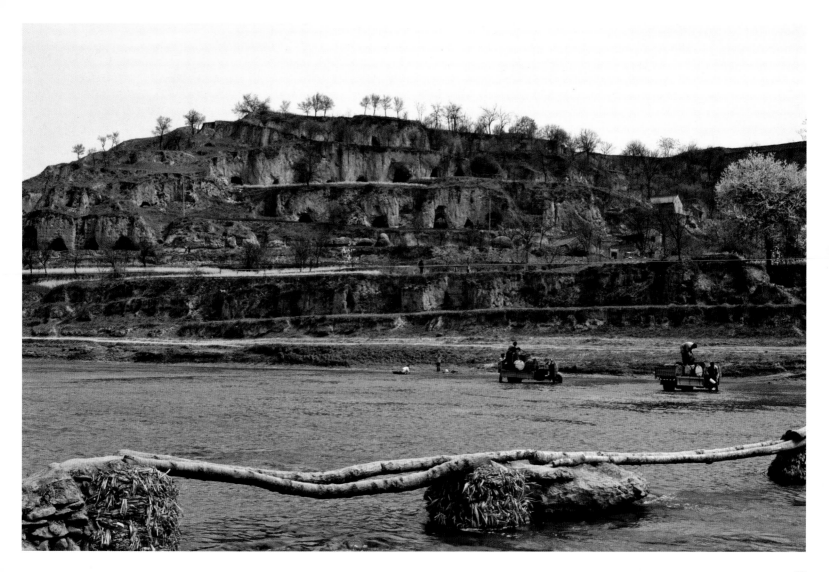

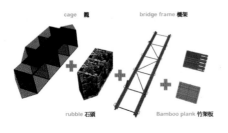

cage 龍 bridge frame 橋架

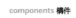

rubble 石頭 Bamboo plank 竹架板

components 構件

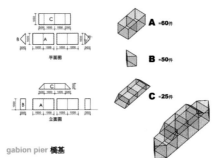

平面圖

立面圖

gabion pier 橋基

A =60件

B =50件

C =25件

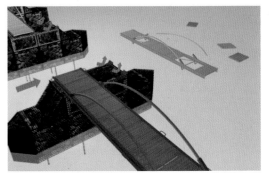

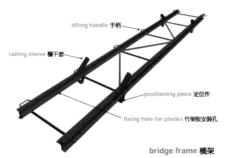

lifting handle 手柄

railing sleeve 欄干套

positioning piece 定位件

fixing hole for planks 竹架板安裝孔

bridge frame 橋架

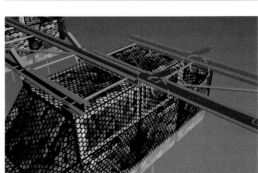

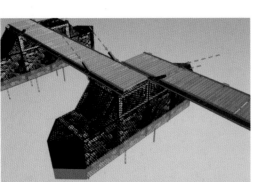

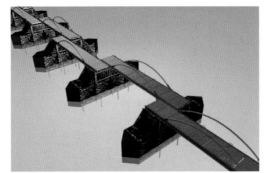

The project is developed in such a way that all the parts have very low costs and can be transported and assembled with a minimum of mechanical devices, operated by volunteers without the need for professional training.

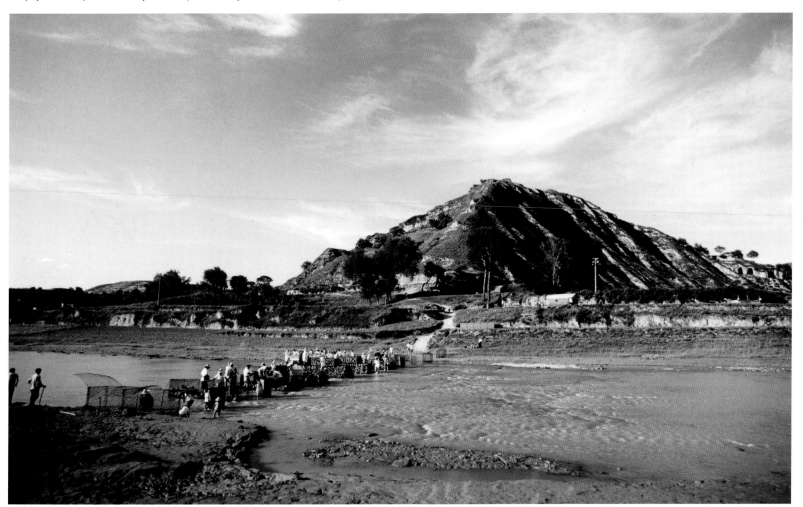

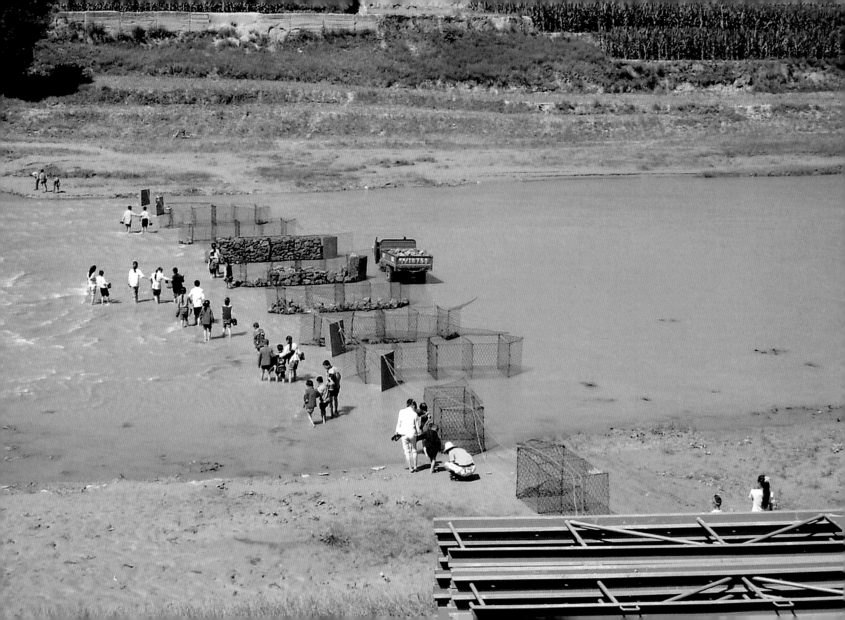

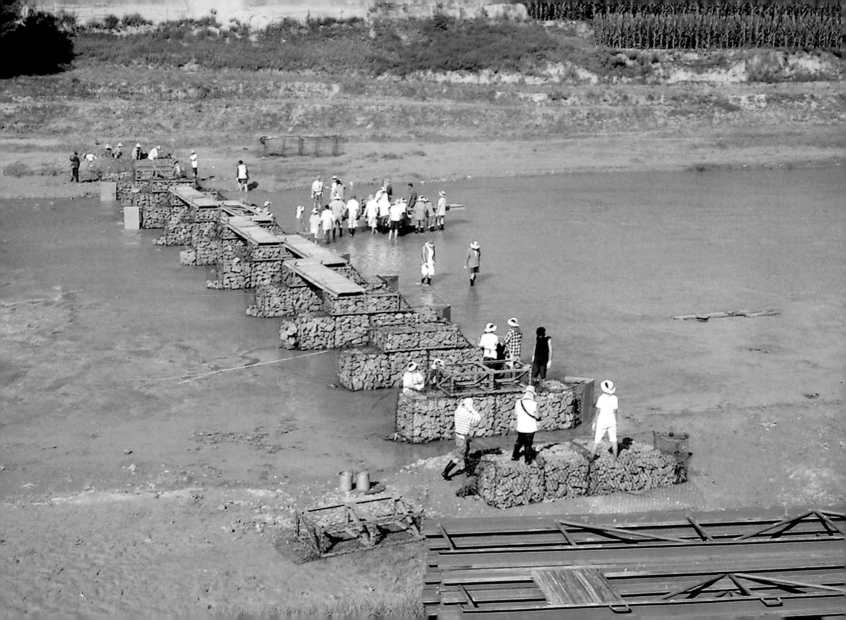

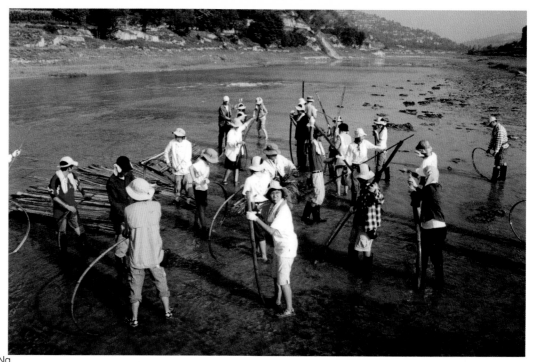

Study of seasonal flooding showed that a bridge raised five feet would remain above the water level for ninety-five percent of the time. Therefore Ng asked Hunt to design a structure that could be flooded, remaining underwater, and then emerge intact. The bridge had to be inexpensive and feasibly built without special equipment, using articles that could easily be procured from the peasants of Maosi. The solution was to construct support piers made with cages filled with stones, without foundations, but shaped and heavy enough not to be moved by the water. Between the two piers the walkway had to be transported and put into place in five minutes, by no more than six persons. The bridge, with a length of 262 feet, was built in 7 days in July 2005 by a group of volunteers consisting of 50 people from Hong Kong, 20 students from the place, and many inhabitants of the village.

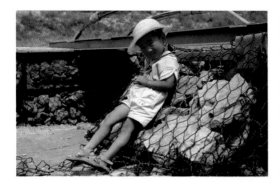

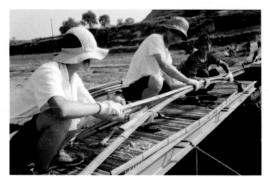

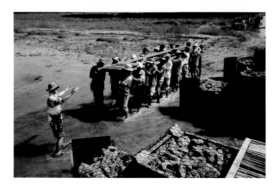

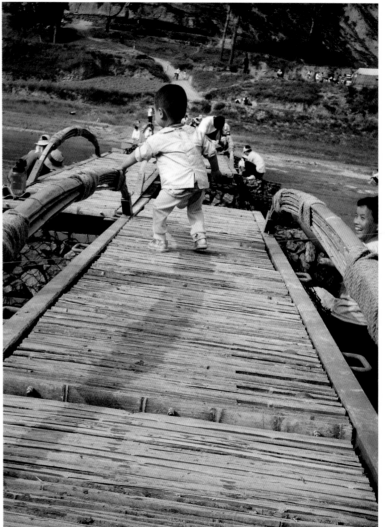

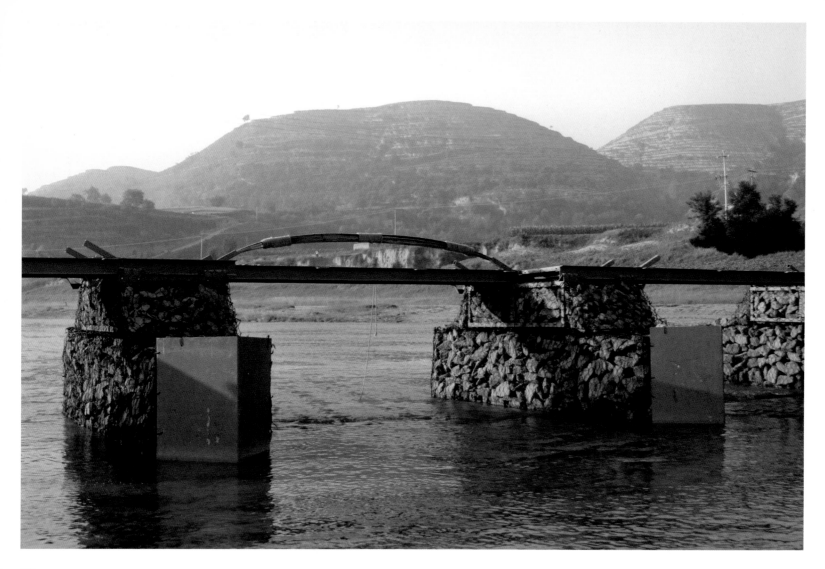

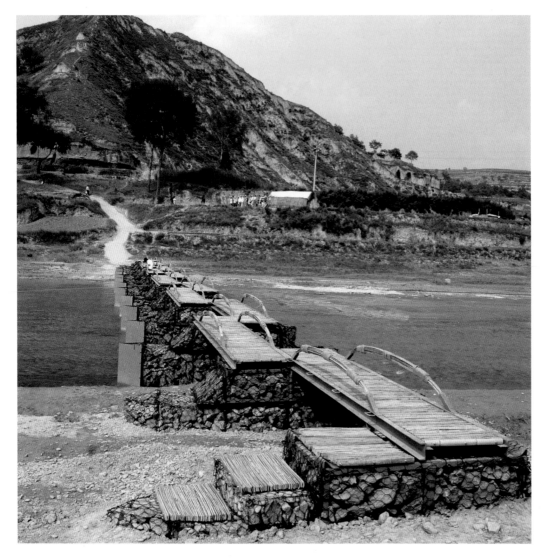

17 July 2005: the bridge is finished.

N ARCHITE

CTS

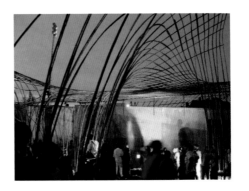

Our work focuses on responsive and flexible design concepts and innovative building techniques that redefine conventional notions of program, type, and context. nArchitects' goal is to achieve maximum effect with an economy of conceptual and material means, and a positive impact on the environment.

–Eric Bunge & Mimi Hoang

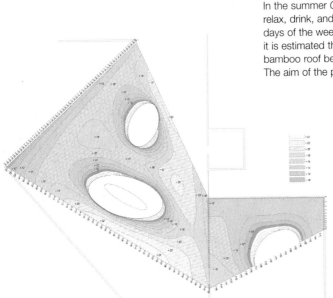

Canopy was a temporary structure made with green bamboo in the courtyard of the P.S.1 Contemporary Art Center. In the summer *Canopy* hosted musical events on Saturday evenings, when museum visitors could listen to music, relax, drink, and dance to music by avant-garde DJs and groups that happened to be in New York. On the other days of the week the space was used in a quieter way, by families and children. During its five months of existence it is estimated that the *Canopy* welcomed about 100,000 visitors. Until it gave in to its slow decline, and the green bamboo roof became dark brown.

The aim of the project was to create a unifying space for different types of crowds: to provide seating, a dance floor, playing areas, and to improve the micro-climate with respect to summer heat. The bamboo weave, a surface of about 3300 square feet, forms the frame for 4 micro-environments, equipped with three different water systems. The project is based on a particular tectonic system to bind together provisions for overhead, seating and various atmospheres, forming a "deep landscape" characterizing the entire space of the courtyard.The dips in the canopy generate outdoor rooms, each with its own specific climate and environment, and each for a particular use: the "Pool Pad" features a swimming pool for children, in polystyrene; the "Fog Pad" is surrounded by nozzles that emit a cool cloud of mist; "Rainforest" has a soundscape with speakers broadcasting sudden downpours, and water misters for surprising instant showers; the "Sand Hump" is a sandy island, ideal for sunbathing or shady lounging. The various levels of humidity and exposure to the sun's rays, the different diameters of the bamboo and the effects of orientation have produced different degrees of transformation in the color and the properties of the material. In the Rainforest the transplanted bamboo, watered every half hour, grew rapidly, producing new stalks. *Canopy* was built in seven weeks by nArchitects and their team of students and young graduates. Before construction the team spent six weeks testing every type of arch, to experiment with maximum sizes, minimum curvature radii and the sizing of overlaps. The structure used almost 10,000 linear meters of freshly cut Philostachys Aurea bamboo, joined and tied with 9000 meters of steel wire.

P.S.1 Contemporary Art Center, Queens, NY, 2004.

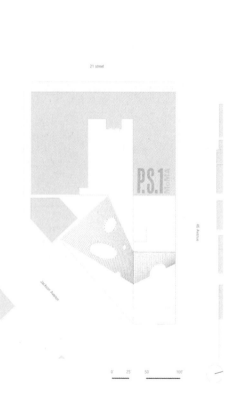

21 street

P.S.1
MoMA

46 Avenue

Jackson Avenue

0 25' 50 100'

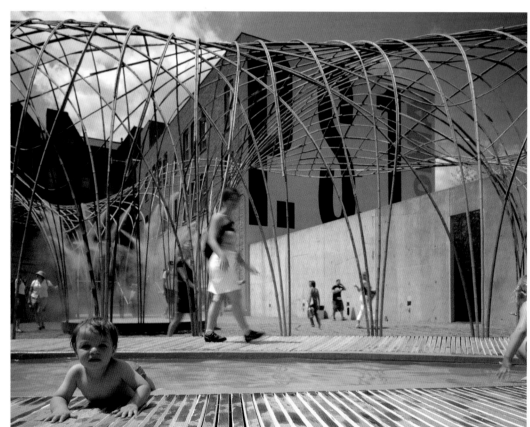

competition project:

nARCHITECTS (Eric Bunge, Mimi Hoang)

Jorge Pereira (Project Architect), Samuel Dufaux, with Kayt Brumder, Phu Hoang, Claudia Martinho, Marica McKeel, Christopher Rountos, Dayoung Shin, Nik Vekic.

installation:

Eric Bunge, Nick Gelpi, Mimi Hoang, Matt Hutchinson, Ian Keough, Jonathan Kurtz, Jeannie Lee, Marica McKeel, Jorge Pereira, Aaron Tweedie, with Anthony Acciavatti, Jenny Chou, Samuel Dufaux, Jennifer Fetner, Toru Hasegawa, Mark Hash, Hikaru Iwasaka, Sebastian Potz, Christopher Rountos, Kevin Sipe, Peter Thon, Nik Vekic.

Bamboo structures consultants: Dave Flanagan, President, Northeast Chapter, American Bamboo Society

Bamboo supplier: Big Bamboo, GA

Steel: Amuneal Manufacturing Corp., PA, nArchitects

Structural consultant: Markus Schulte, Ove Arup & Partners, NY

Garden consultant: Marie Viljoen, NY

Sound setting: José Ignacio Hinestrosa

Sand Hump

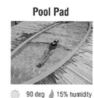

100 deg 5% humidity

Pool Pad

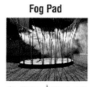

90 deg 15% humidity

Fog Pad

80 deg 90% humidity

Rainforest

70 deg 100% humidity

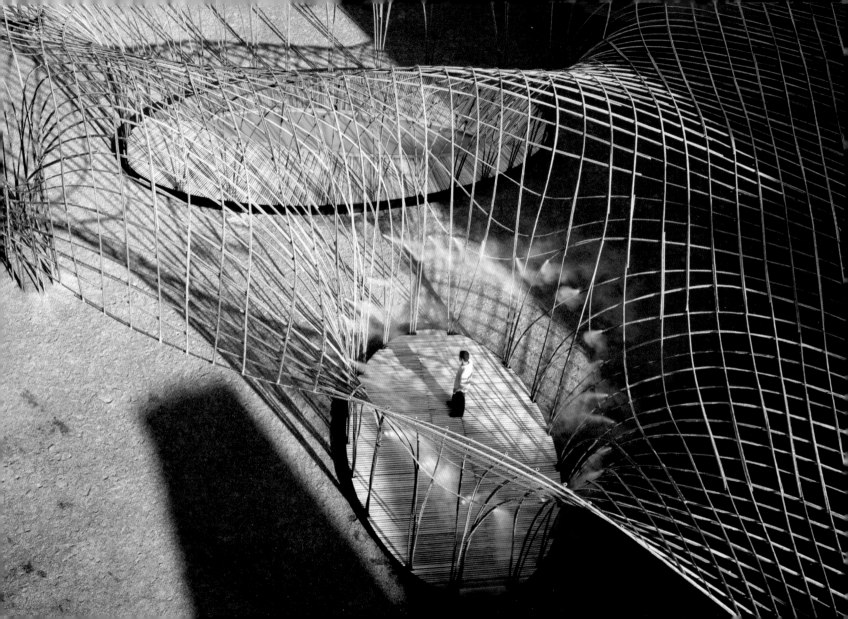

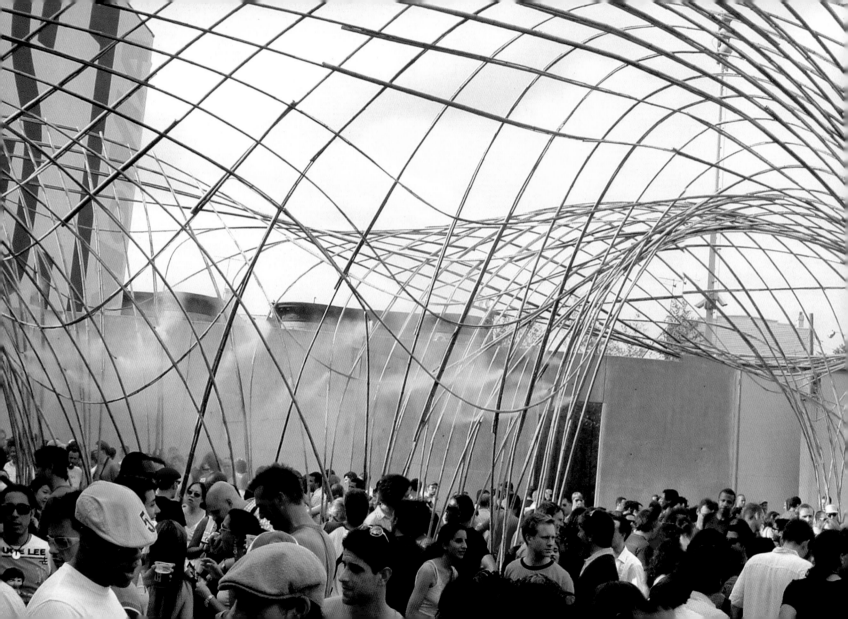

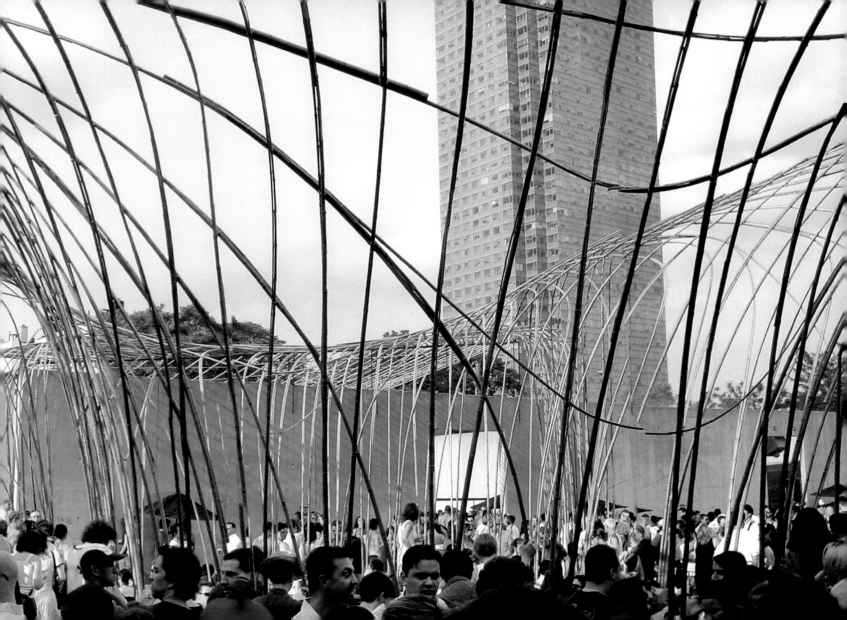

The team began construction in small areas, first erecting the support arches with the largest spans, and then the non-structural arches, repeating the sequence until the definitive form was achieved. Each arch was assembled on the ground using steel wire to attach the twenty-two-foot bamboo poles and marking each intersection point.
With the ends clad in neoprene, the structural arches were inserted in steel pipes welded to the ring beams or to tie-rods attached to the walls.

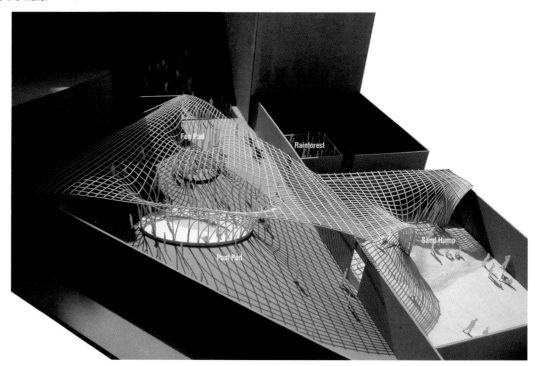

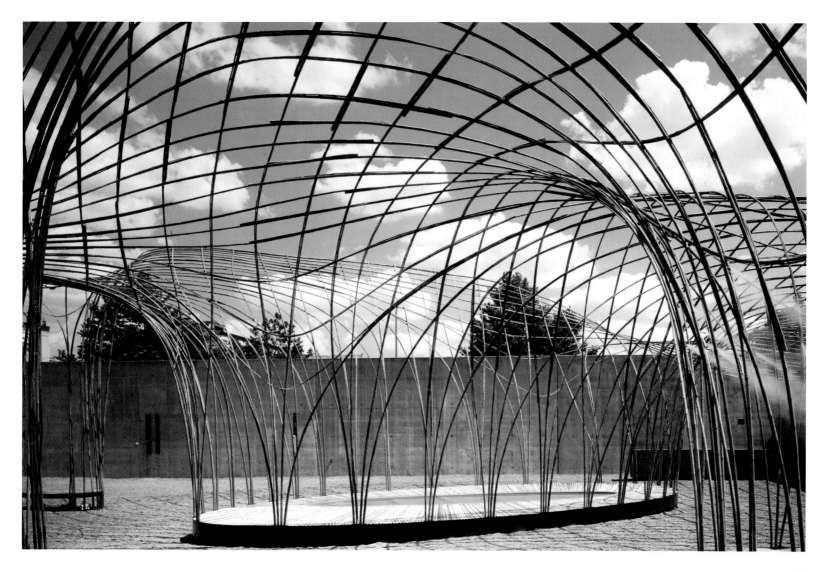

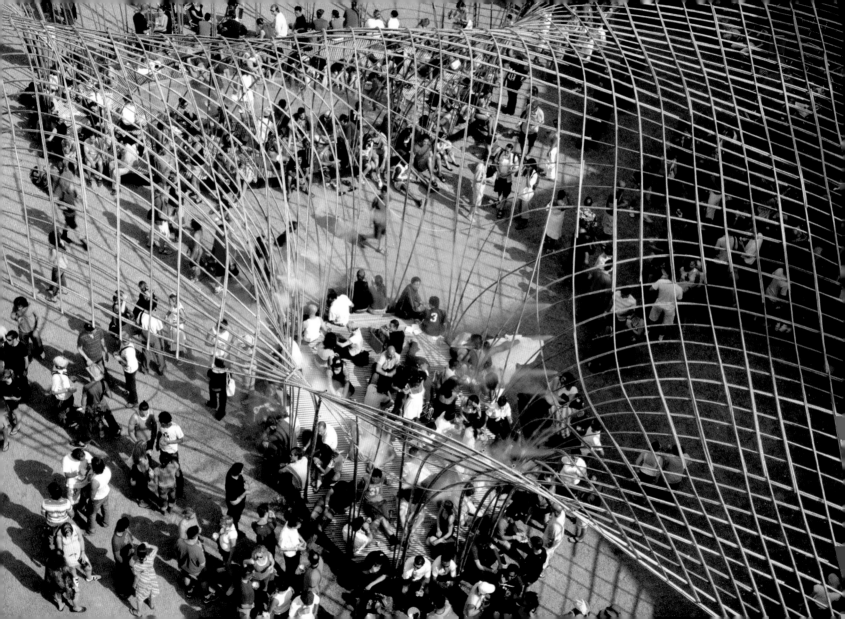

OLAFUR EL

IASSON

Olafur Eliasson uses elementary and ephemeral materials: light, warmth, humidity, steam, and ice are manipulated with aesthetic aims and in relation to the specificities of the site. His work navigates freely between nature and technology, organic and industrial.

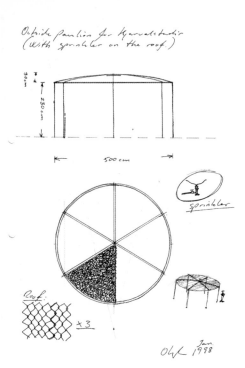

Ice pavilion Kjarvalstadir, Reykjavik Art Museum, 1998. Material: steel, water, sprinkler. 118 x 98 inches

The structure is composed of slender metal supports topped by a circle, also in metal, wrapped by a garden hose from which water drips.
As the temperature descends below 32°F, the water freezes and forms a roof covering the pavilion. Its circumference is covered with transparent veils of thin ice that slowly descend to the ground, making the sculpture, and the cold winter, fully visible.

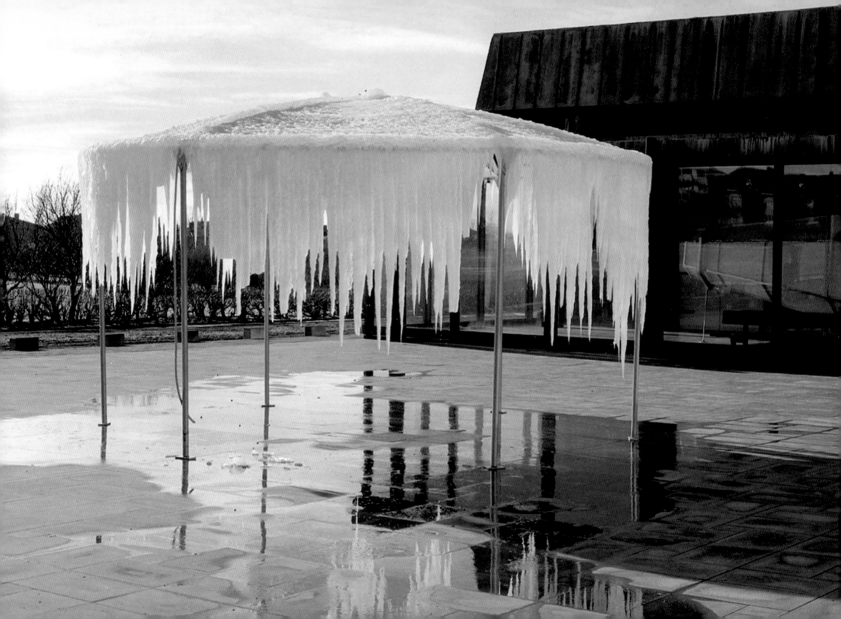

EX.STUDIO

The visitor sits between two thatched walls, excluded
from the view of the horizon. A fragment of landscape
remains visible, accompanied by the odor of the straw,
the singing of the birds, the sound of the wind…

–P. M. & I. J.

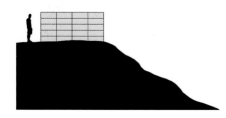

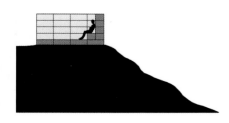

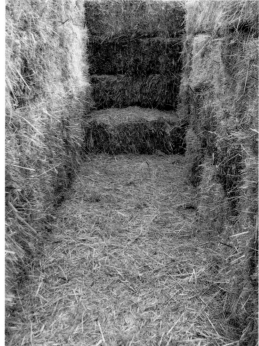

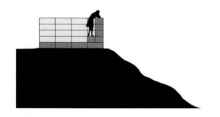

An observatory of the architectural, historic, and landscape context of Casale Marittimo. Arriving from the ancient Roman road that leads to Casalevecchio one glimpses, on the top of a small hill, a compact volume formed by bales of hay harvested at the site. Approaching, the observer discovers that the volume is actually a perspective space formed by two walls. Entering and crossing the object, the perception of space changes. The visitor senses the sound and consistency of the material underfoot, and then a step leads to a raised point for viewing the medieval town, the Tyrrhenian coast and the islands of the Tuscan archipelago. A new perception comes when the step is used as a bench, where the visitor sits between two straw walls, unable to see the horizon. A fragment of landscape remains visible, accompanied by the odor of the straw, the singing of the birds, the sound of the wind.

Point Of View. Belvedere in Toscana Casale Marittimo, Pisa, Italy, 2005.
Ex.Studio Patricia Meneses + Iván Juárez with Emanuele Guidi (curator) in collaboration with the Possemato family and Patrizia Mussi.

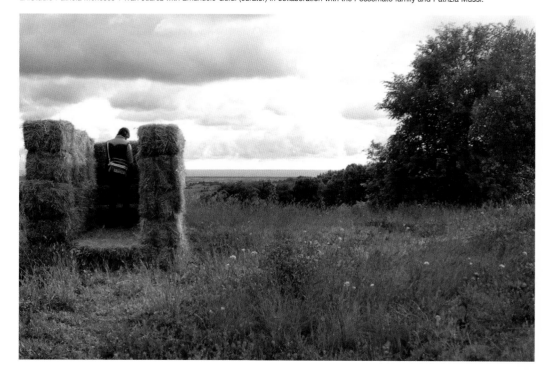

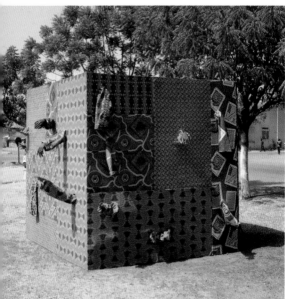

Tambabox Tambacounda, Senegal, 2005. Ex.Studio Iván Juárez + Patricia Meneses.

single frames

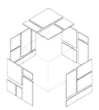

axonometric

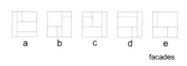

a b c d e

facades

d

a e c

b

assembled piece

plan section

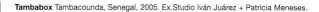

Tambacounda, east of Dakar, is one of the poorest regions of Senegal, but it has great cultural wealth thanks to the survival of traditions, and the intense relationship of exchange with five neighboring countries: Gambia, Mali, Mauritania, Guinea Konakry and Guinea Bissau. Tambabox is a spatial object derived from the fabrics, with extremely varied, complex designs, that most of the population uses for tunics. The project constructs an interior bordered by an assemblage of fabrics that filter and tint the natural light. During the day the color of the light varies in a series of different tones and shades. At night the space becomes an illuminated multicolored box that stands out in the darkness, while the shadows of bodies are projected and revealed on the fabric. For the construction we worked with local craftsmen, carpenters and tailors, and the work was offered as an open space for encounters of different artforms from a single tradition: dancers, musicians, actors, and painters.

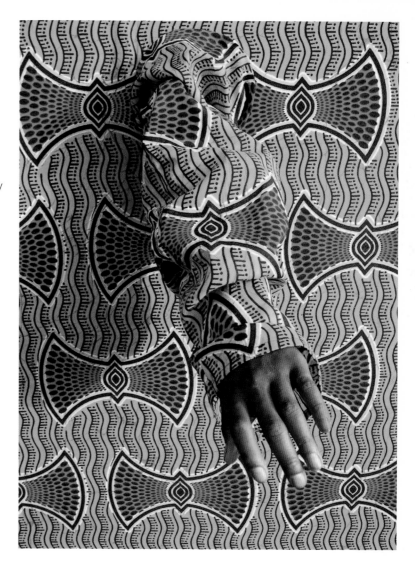

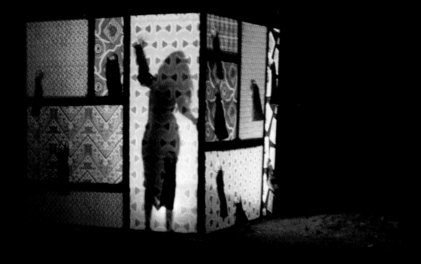

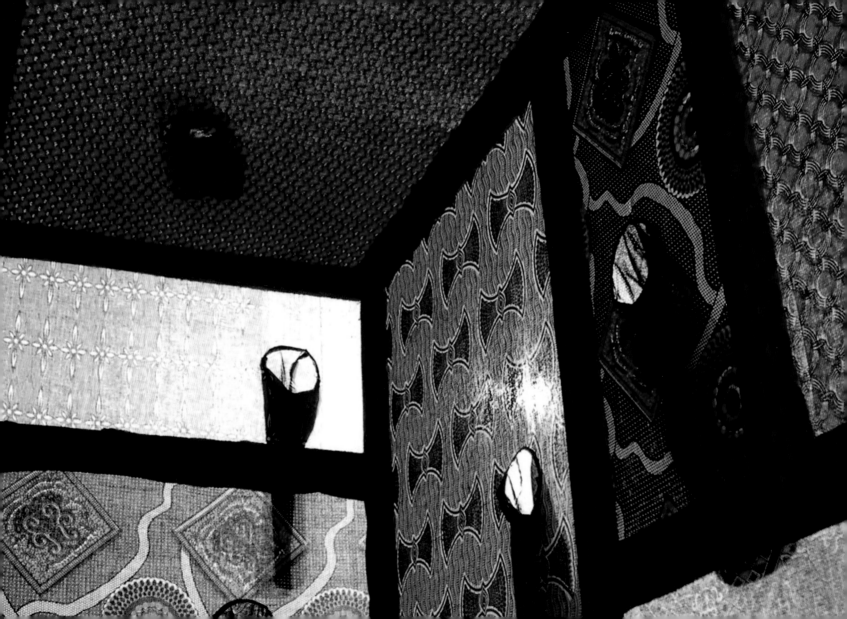

BIBLIOGRA

APHY

Andrews, Julian. *The Sculpture of David Nash*. London: The Henry Moore Foundation in association with Lund Humphries Publishers, London, and Berkeley: University of California Press, 1999.

Besacier, Hubert. *Nils Udo: Art In Nature*. Paris: Flammarion, 2002.

Carugati, Decio Giulio Riccardo. *Giuliano Mauri*. Milan: Electa, 2003.

Drury, Chris. *Silent Spaces*. London: Thames & Hudson, 1998.

Eliasson, Olafur. *The weather project*. London: Tate Modern, 2003.

Eliasson, Olafur. *Minding the world*. Århus, Denmark: ARoS Århus Kunstmuseum, 2004.

Eliasson, Olafur. *Your Lighthouse: Works with Light 1991–2004*. Wolfsburg, Germany: Kunstmuseum, 2004.

Eliasson, Olafur. *Frost Activity*. Reykjavik: The Reykjavik Art Museum, 2004.

Fagone, Vittorio, ed. *Art in Nature*. Milan: Mazzotta, 1996.

Fagone, Vittorio. *Giuliano Mauri: Arte Nella Natura 1981–1993*. Milan: Mazzotta, 1993.

Garraud, Colette. *L'idee de nature dans l'art contemporain*. Paris: Flammarion, 1994.

Giovannini, Wanda and Laura Tomaselli. *Arte Sella 2004*. Rovereto, Italy: Nicolodi, 2005.

Grande, John K. *Art Nature Dialogues: Interviews With Environmental Artists*. Albany, N.Y.: State University of New York Press, 2004.

Kalberer, Marcel and Micky Remann. *Grüne Kathedralen*. Aarau, Switzerland: AT - Verlag, 2003.

Kalberer, Marcel and Micky Remann. *Das Weidenbaubuch*. Aarau, Switzerland: AT - Verlag, 1999.

Kastner, Jeffrey and Brian Wallis, ed. *Land and Environmental Art*. London: Phaidon, 1998.

Laaksonen, Esa. "Living architecture, Vegetal building," in *The Architectural Review* 1259 (2002).

Manguelin, Eric and Francois Méchain. *L'exercise des choses / the exercise of things*. Saint Julien Molin Molette, France: Jean-Pierre Huguet, 2003.

Nash, David. *Forms into Time*. London: Academy, 1996.

Nils-Udo. *Nids*. Paris: Editions Cercle d'Art, 2003.

Rocca Alessandro. *Natura artificialis : il progetto dell'ambiente e l'architettura del paesaggio*. Milan: Clup, 2003.

Rudofsky, Bernard. *Architecture without Architects: A Short Introduction to Non-Pedigreed Architecture*. Garden City, N.Y.: Doubleday & Company, 1964.

Slavid, Ruth. *Wood Architecture*. London: Laurence King, 2005.

Sonfist, Alan, ed. *Art in the Land: A Critical Anthology of Environmental Art*. New York: E.P. Dutton, 1983.

Strelow Heike, ed. *Ecological, Aesthetics, Art in Environmental Design: Theory and Pratice*, initiated by Herman Prigann, in cooperation with Vera David. Basel and Boston: Birkhaüser, 2004.

Strelow, Heike, ed. *Natural Reality: Artistic Positions between Nature and Culture*. Stuttgart, Germany: Daco Verlag, 1999.

Sutton, Gertrud Købke. *Mikael Hansen*. Copenhagen: North, 2003.

Tiberghien, Gilles A. *Nature, art, paysage*. Arles, France: Actes Sud, 2001.

Tiberghien, Gilles A., ed. *Land Art*. Paris: Edition Carré, 1995.

THE AR

JACKIE BROOKNER Ecological artist, she works collaboratively with ecologists, design professionals, communities and policy makers on water remediation/public art projects for wetlands, rivers, and stormwater runoff—with recent and current projects near Dresden, Germany; in West Palm Beach, Florida; Cincinnati and Toledo, Ohio; and New York. Her projects demonstrate how the undervalued resources of stormwater and other polluted water can be reclaimed and used to create lush environments and multifunctional public spaces. They range from Biosculptures™ that are vegetated water filtration systems, to municipal planning where local water resources become the focal point of community revitalization. She lives and works in New York and teaches at Parsons School of Design.
Website: www.jackiebrookner.net

B - B. BRUNI BABARIT / BABARIT BRUNI Gilles Bruni was born in 1959 in Nantes, Marc Babarit in 1958, at Cholet. B/B was formed in 1985 at Saint-Philbert-de-Grand-Lieu and is based in France, in the Loire region, working around Europe and the rest of the world. After having studied agriculture in the 1970s, Bruni and Babarit both experimented, independently, with painting and sculpture. In the 1980s they abandoned their artistic pursuits to join forces on neutral ground. At the same time they studied art at the University of Rennes until the mid-1990s. Since then they have divided their time between teaching and field work, in France and abroad (Germany, United States, Canada, Denmark, Italy, Austria, Venezuela). Recently they participated in the group show "Eco-photo" in Long Island City, New York, and the Open Air Art Biennial of Caracas.
Website: www.bruni-babarit.fr

PATRICK DOUGHERTY Combining his carpentry skills with his love for nature, he began to learn more about primitive techniques of building and experimented with tree saplings as construction material. In 1982 his first work, MaplyBodyWrap was included in the North Carolina Biennial Artists' Exhibition and in the following year he had his first one person show at the Southeastern Center for Contemporary Art in Winston-Salem. His work quickly evolved from single pieces on conventional pedestals to monumental scale environments which required saplings by the truckloads. During the last decade he has built over one hundred works throughout the United States, Europe, and Asia.
Website: www.stickwork.net

TISTS

CHRIS DRURY Born in Sri Lanka in 1948, he studied in England. His work is often categorized as Land Art, but in reality he sees himself as an artist who looks for connections in the world; connections between: Inner and Outer, Nature and Culture, Microcosm and Macrocosm. He employs a diverse range of materials and processes; from architectural works, to works of several acres in scale, to small works on paper. He has traveled and walked in out-of-the-way places, often alone. More recently he has been exploring systems of flow in the body with similar systems on the planet, collaborating with radiologists and ecologists. He will be extending this research to Antarctica where he will be spending two months from December 2006. He has also worked extensively with small communities in Europe, Japan, and America. He has exhibited widely in Europe, America, and Japan and has had many one-person shows in Britain, Ireland, and America. His site specific public works are in Britain, Japan, Denmark, and America. Website: www.chrisdrury.co.uk

OLAFUR ELIASSON Born in 1967 in Copenhagen to Icelandic parents, he studied at the Royal Academy of Arts of Copenhagen from 1989 to 1995. In his art career he has always used the materials of climate, humidity, luminosity, temperature, and pressure. By calling into play natural phenomena like water, fog, or light, the artist stimulates spectators to reflect on their ability to comprehend and perceive the physical world around them. Eliasson has participated in many international exhibitions, and his work is included in many public and private collections, including those of the Guggenheim Museum of New York, MoCA of Los Angeles, and the Tate Modern of London. He has held solo shows and installations at the Kunsthaus of Bregenz, the Musée d'Art Moderne de la Ville de Paris and ZKM (Center for Art and Media) in Karlsruhe, and he represented Denmark at the Venice Biennale in 2003. His most important installations include The Weather Project, created in 2003 for the Turbine Hall of the Tate Modern. He now lives and works in Berlin. Website: www.olafureliasson.net

EX.STUDIO Patricia Meneses (1976, San Luis Potosi, Mexico) and Ivan Juarez (1972, Mexico City), both architects, have opened a studio in Barcelona. Their projects explore the relationship between art and function, integrating architecture and design, sculpture, and art installation. They have participated at the Biennial of the European Landscape of Saint-Etienne and their projects have been shown at the headquarters of the Royal Institute for British Architects (Riba), the Coac of Barcelona, and other galleries. They have given lectures in schools in England and Spain, and, in 2005, they received an honorable mention at the Architectural Record Awards. In 2006 they won the competition for a public space in Navacerrada, Spain. Website: www.ex-studio.net

MIKAEL HANSEN (1943, Aarhus, Denmark). After training as a graphic designer, in 1975 he settled in Albertslund, a suburb of Copenhagen, near a highway. The desolate landscape of the suburbs and their infrastructures has greatly influenced his work. The second particularly important landscape, for Hansen, is that of the forest of Vestkoven, an artificial forest of nine square miles that he has chosen as his workshop. In 1965 he made charcoal drawings; three years later he held shows of oil paintings; and starting in 1975 he began to concentrate on art full time, with regular shows at the Galleri Sct. Agnes of Copenhagen. An important passage for his naturalistic work was the group show Projekt Vadehav, in 1983, followed by a series of works on nature, the elements of the rural and agricultural landscape, alternating sculptures and Land Art installations. He has worked extensively abroad, participating in various art initiatives in Italy, Germany, Holland, Norway, Sweden, Japan, and Korea. Website: www.mikael-hansen.dk

ICHI IKEDA (1943, Osaka, Japan). Ikeda's art is very strongly connected with global environmental problems, especially concerning water. Ichi Ikeda consistently uses water as his medium, exploring new visual expressions with this uncontrollable substance. Ikeda Water's most important projects are Water Mirror, Waterhenge, the United Waters, Manosegawa River Art Project, 80,000 Liter Water Box, Water's-Eye project etc. Since 1997, he has been developing the worldwide project entitled World Water Ekiden, with the idea that any place can function as the starting point for forwarding "water for the future" to the next generation living on the Earth. His art serves as a catalyst for change and an inspirational focal point for the exchange and circulation of information related to water conservation.
Website: www33.ocn.ne.jp/~waters

YUTAKA KOBAYASHI (born in Tokyo, Japan). Since receiving his Master of Fine Arts from Parsons School of Design, New York in 1991 Kobayashi's work has been shown in numerous exhibitions in New York and throughout Japan, including Echigo-Tsumari Art Triennial. In addition to ecological, site-specific installations in the USA, Canada, Turkey, Korea, Venezuela, and Japan, he has been working on designing and implementing new school and community-based art projects. He has received an overseas fellowship from the Japanese Ministry of Culture & Education, and is an artist-in-residence at Otis College of Art and Design and California College of Arts and Crafts. He is a professor of Fine Arts at the University of Ryukyus in Okinawa, Japan, and a member of the mayor's urban planning cabinet for the city of Naha.
Website: greenarts.net

GIULIANO MAURI Born in Lodi Vecchio in 1938, at the end of the 1960s he came into contact with the leading Italian art avant-garde movements. In 1976 he participated at the Venice Biennale, and in 1978 he created an enormous board game at the Museum of Modern Art of Bologna for the exhibition Metafisica del quotidiano. In 1982 he constructed the imposing *Paradise Staircase* (460 feet long x 32 feet high) on the banks of the Adda River where, in 1984, the series of the *Botanical Altars* began. Other important works include the large Mills that spin in an imaginary wind, and the Forest on the Island at the source of the Tormo, near Lodi. In 2001, for Arte Sella, he built the *Botanical Cathedral* and, in the sphaeristerium of Macerata, the set of the production of *Norma* for Claudio Abbado. In 2003, for the exhibition Le città invisibili at the Milan Triennale, he created *Zenobia*, a large nucleus of woven branches, and *Song Reactor*, a 65-foot cupola built around a spring at Carvico, Bergamo. In 2005, at Villacaccia di Lestizza (Friuli), he began the construction of a large circular temple: eighteen hollow pillars in chestnut wood taken from the scrap after the pruning of nearby hillside woods, will guide the growth of hornbeam trees. Mauri has made and shown works in many galleries in Italy and abroad: Copenhagen, Dresden, St. Louis, New York, Goerlitz, Stuttgart, and Lanzarote.

FRANÇOIS MÉCHAIN Born in 1948 in Varaize, France, he lives and works in Charente. He is a nomadic sculptor, who, by invitation or through his own initiative, intervenes in natural settings, parks, gardens, and, at times, in cities (Paris, Dresden), utilizing his own materials and materials found on the site. He works outdoors with his bare hands, without the aid of mechanical tools, and develops his projects, in substance, as things to be photographed. In effect the final result of his work is not just the on-site installation, which may exist for two or three months, but also its photographic documentation, which he defines as "laboratory sculpture." As an artist-in-residence he has been invited to create site-specific works in Germany, Belgium, Canada, Denmark, Spain, Finland, Great Britain, Greece, Italy, Luxembourg, Portugal, the United States, France, and elsewhere. His latest exhibitions include the recent retrospective at Galerie Michèle Chomette in Paris and the exhibition in Saragoza, in 2006, the solo shows at Ile de la Réunion and Santiago de Compostela in 2005, and in Chicago in 2001 and 2003.
Website: francoismechain.com

nARCHITECTS It was founded in New York City by partners Eric Bunge and Mimi Hoang in 1999. Their work focuses on responsive and flexible design concepts and innovative building techniques. nARCHITECTS' goal is to achieve maximum effect with an economy of conceptual and material means, and a positive impact on the environment. Mimi Hoang, born in 1971 in Saigon, received a Master of Architecture from Harvard University, and a Bachelor of Science in Architecture from M.I.T. She teaches graduate design studios at Yale University and has taught at the University of California, Berkeley. Prior to co-founding nARCHITECTS, she trained in New York, Boston, and Amsterdam. Eric Bunge, born in 1967 in Montreal, received a Master of Architecture from Harvard University and a Bachelor of Architecture from McGill University. He teaches graduate design studios at Parsons School of Design. Prior to co-founding nARCHITECTS, he trained in New York, Boston, Paris, Calcutta, and London. Among their recent works, *Wind Shape*, a temporary installation realized in Lacoste, France and a project for the Toronto waterfront.
www.narchitects.com

DAVID NASH Born in Esher, Surrey, in 1945, he studied at Kingston College of Art (1963–64), Brighton College of Art (1964–67), and Chelsea School of Art (1969–70). On leaving Chelsea, Nash moved to Blaenau Ffestiniog in North Wales, purchasing a chapel that has remained since then both his studio and home. Working away from London allowed Nash the intellectual and physical space to develop his art. He not only carves wood, largely from fallen trees, with chain and milling saws—skills that he has perfected over the years—but he also creates sculptures from growing plants, cutting and training them into domes or ladders. Many of David Nash's exhibitions – he has had hundreds of solo and group shows throughout the world—are formed from work he has made in the general location of the museum or art gallery, with local wood. In 1999 David Nash embarked on making some works in bronze, using earth and fire in the process. The resulting sculptures, with their patina resonant of smoke and ash, hold echoes of his works in wood. Nash continues to work in Blaenau Ffestiniog and in many places around the world. In 1999 he was elected to the Royal Academy.

EDWARD NG He is an Architect and a Professor at the Chinese University of Hong Kong (CUHK). He is director of the M.S. Sustainable and Environmental Design Program at CUHK. He was educated in the UK and obtained his Ph.D. from Cambridge University. Since then he has been practicing as an architect and lecturing in various universities. His specialty is Environmental and Sustainable Design. He is working as an environmental consultant for the Hong Kong government, he is visiting professor at Xian Jiaotong University, China, and he is designing ecological schools, and building charitable projects in the region. His design works have been exhibited in the UK, France, Germany, Singapore, and Hong Kong; and he has been recipient of national and international design awards, including the AR Emerging Architecture Award and the RIBA International Award.
Website: www.edwardng.com

NILS-UDO (born in Lauf, Germany, in 1937). After a beginning as a painter, in Paris, in 1972 he chose to work directly with natural elements, and since then he has made a great many site-specific installations all over the world using leaves, branches and logs, berries, and any other organic material found in the place he is working. In his work the beauty of nature is revealed in the manipulation and alteration caused by the intervention of the artist. Starting in the 1980s he has shown his works all over the world in group and solo shows. Recent works include the monumental *Nest* made for Buga 2005, in Munich, and the *Clemson Clay Nest* in Clemson, South Carolina. His latest solo shows have been held in Turin and Tokyo, in 2005, Madrid and Tokyo in 2006.

SANFTE STRUKTUREN / MARCEL KALBERER (1947, San Gallo, Switzerland). He studied architecture at the Hochschule für Gestaltung of Ulm, the Pratt Institute of New York, and the University of Stuttgart. He has conducted structural research and taught at the University of Stuttgart and Bonn. In 1977 he founded Sanfte Strukturen, an atelier for experimental architecture. First in Stuttgart and then in Herdwangen/Überlingen, the studio has worked on research and construction with natural materials: willow, bamboo, rushes. On his own and with Sanfte Strukturen he has published eight books, including *Das Weidenbaubuch*, Aarau 1999, and *Grüne Kathedralen*, Aarau 2003, both written with Micky Remann. He has designed many buildings and public spaces, especially in Germany, utilizing natural and living materials and making use, for the construction, by groups of volunteers.
Website: www.sanftestrukturen.de

ARMIN SCHUBERT (Lustenau, Austria, 1950). He began his career as a painter, draftsman, and photographer of landscapes and nature. Then he approached Land Art and Arte Povera, teaching himself by studying the works of Richard Long, Andy Goldsworthy, Chris Drury, James Turrell, Nils-Udo. Working on the themes of the Art in Nature movement, he began to experiment with different techniques, materials, and environments, making sculptures, installations, and assemblages in stone and wood. He maintains a profound relationship with his village, where he does most of his work, though he has also participated in international events in Lofoten, Norway; Voralberg, Austria; and in the Arte Sella event at Borgo Valsugana.
Website: www.armin-schubert.at

CREDITS

The illustrations published here come from: **David Nash**, pp. 13-21; **Bruni & Babarit**, pp. 23-35; **Mikael Hansen**, pp. 37-45; **Giuliano Mauri**, pp. 47-61; **Sanfte Strukturen**, pp. 63-73; **Ichi Ikeda**, pp. 75-85; **Jackie Brookner**, pp. 87-93; **Yutaka Kobayashi**, pp. 95-101; **Nils-Udo**, pp. 103-117; **François Méchain**, pp. 119-123; **Ian Krticha**, p. 126; **Bernard Rudofsky**, pp. 127-131; **Armin Schubert**, pp. 133-145; **Chris Drury**, pp. 147-159; **Patrick Dougherty**, pp. 161-171; **Edward Ng**, pp. 173-183; **nArchitects**, pp. 185-195; **Olafur Eliasson**, pp. 197-199; **Ex.Studio**, pp. 201-207.

The illustrations published here have been courteously supplied by the architects of the works described. The author and publisher would like to thank them all for their cooperation and for the generosity with which they have participated in the creation of this book. Without their support, trust, and friendship this project would not have been possible. The main motivation behind the creation of this book is the conviction that their work, enthusiasm, and art make us better, more attentive, more aware of the fact that, in order to live happily, man must continuously redefine the terms of his relationship with nature, constructing new opportunities for knowledge, faith, imagination, and love.